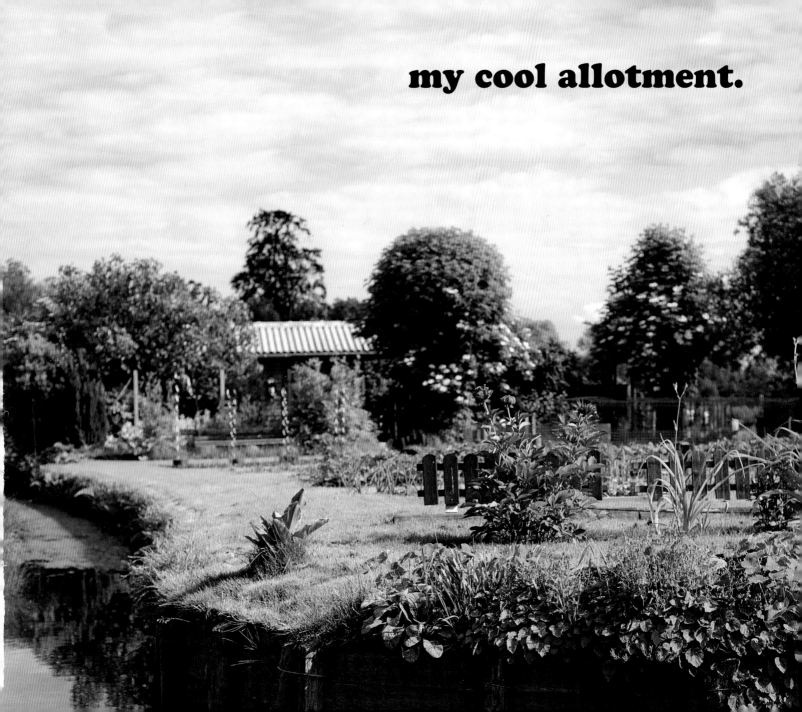

my cool allotment.

my cool allotment.

an inspirational guide to allotments and community gardens

lia leendertz

photography by **mark diacono**

PAVILION

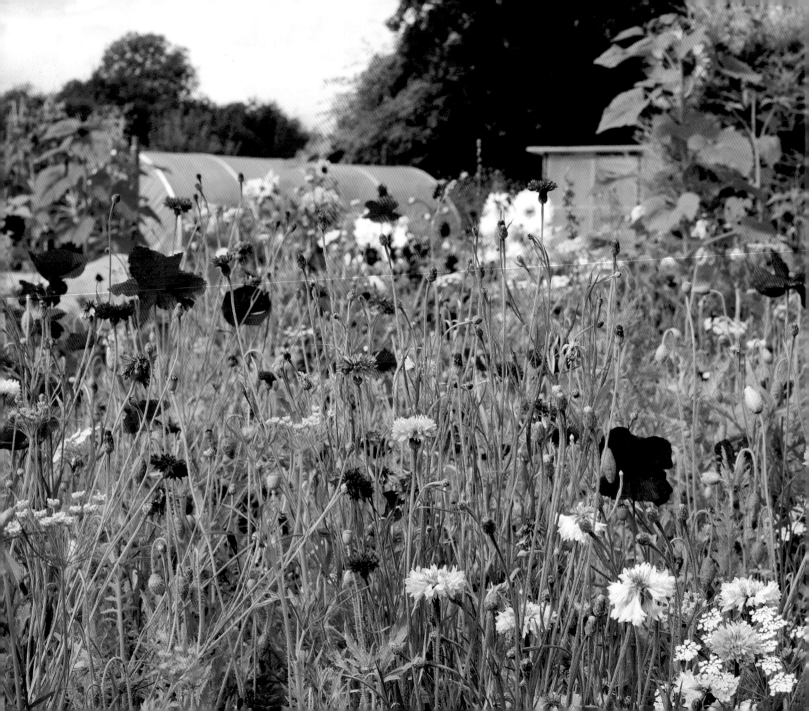

contents

introduction

This is a very simple book: all we have done is visited 31 allotments and edible gardens, taken some pictures, and asked the plot holders some questions. But each of these gardeners works a plot or a site that we have deemed beautiful, interesting or unusual enough to be worthy of celebrating. A few private gardens have snuck in among the publicly-owned and rented allotment gardens, where the owners are doing something particularly interesting and edible, and a good smattering of amazing community gardens have found their way in too, but this is primarily a book about allotments, and their wonderful variety.

I am an allotment holder, and have been on my current plot for seven years. It became obvious very early in the researching of this book that I was about to embark on a sort of allotment holder's pilgrimage. I found myself getting pathetically excited about the plots we were planning to visit. The oldest site in the UK! A Jamaican grower of callaloo and okra! A plot entirely devoted to growing natural dyes! The opportunity to travel around this many allotment sites and see how other people do it made my mouth water.

Allotments grew from need: from the late 1700s and into the 1800s people struggling to make ends meet and to fill hungry bellies were allotted a plot of land on which they could grow vegetables. The size of each plot was designed to be large enough that it would produce enough to ease hardship, but not so large that the holder could make his or her living from it. So they were created from a philanthropic impulse, but were also designed to keep workers just happy with their lot at a time when mass riots and upheaval over working and living conditions were threatening the new industrial status quo. They were an effective pressure valve. The first chapter 'Historic' is filled with sites that have their roots in these early troubled days of the allotment movement, including a plot from the oldest allotment site in England.

In keeping with this history allotments have always primarily been places for edibles and not for ornamentals, with allotment rules enforcing vegetable dominance. But as time has gone on and need has become less pressing, so allotment rules have relaxed, and now many plot holders use their little piece of land to create beautiful gardens, or to grow flowers. The second chapter 'A feast of flowers' visits those allotment holders that – each for entirely different reasons and to very different results – fill their plots with flowers.

Chapter 3 'All for One' features those allotments and edible gardens that are run communally. Gardens featured range from a grand scale project where a whole village has taken over a local field for food growing, to my own plot, on which several families and my own rub along together. Like many of the growers in this chapter, we are finding that the practical and moral support of a group of like-minded people makes growing your own food more manageable, and much more fun.

Far from the traditional ideal of the new and tidy allotment plot are those plots to be found in chapter 4, 'Edible jungle'. These are the plot holders finding alternatives to the old ways, and among them are some of the most innovative and forward thinking of growers. These are gardens filled with perennial edibles rather than the traditional and high maintenance annuals, and experiments with polycultures – a type of planting where different vegetables are mixed up together, so confusing and thwarting pests and diseases. Ideas in this chapter may well become more familiar and be seen more widely as climate change makes traditional annual crops trickier to grow.

As allotments are often the only available land near inner cities, they have always been great centres of diversity, and chapter 5 'Food from home' celebrates those plot holders who have brought ideas, plants and recipes from other parts of the world and introduced them to their plots. For these gardeners, working the earth and growing familiar food has proved a way to feel connected to a new environment while at the same time holding onto precious memories and tastes. The chapter features growers from Cyprus, Jamaica, Thailand and Japan, all of whom grow food that is not found on the average plot.

The final chapter 'The creative process' is about those artists and artisans who use their plots primarily in pursuit of an end product: jams, wines, honeys, dyes, or more abstract ideas. These are single-minded growers dedicated to their own individual cause, often fully immersed in the world of the product they are trying to create, and using their plot of land as a means to that end.

Among the allotments featured in this book are some remarkable individual plots, while others are stunning sites, perched on the edge of a cliff in Devon or running alongside a graffiti-covered train platform in Paris. While the plots are varied enough, the plot holders themselves march to entirely different drums. There is certainly no such thing as a typical allotment holder. In here you will find a good old boy who likes things neat and tidy, and for whom the traditional way of growing is still the only way, and an exhibition dahlia grower who devotes all of his energies and time to creating the most perfect blooms imaginable, just as his father did before him. These are the people we used to think of as typical allotment holders, no longer the dominant force, but still very much a part of the fabric. But here also is the artist growing colourful flowers that match her canvases, the environmental and community campaigner using the allotment to create a vision of an alternative future, and the Cypriot grandmother finding memories of her childhood garden in the fresh vine leaves she grows to pluck and stuff full of delicious fillings. Many are artists, some self-proclaimed, others unknowing. What has been most remarkable has been witnessing just what different people do in response to a small piece of land. Each plot is an expression of the allotment holder's personality, memories, hope and fears.

This is a collection of the best plots we could find, but it is also a snapshot of today's allotment culture. Taken together, these 31 plots paint a picture of the way allotments are at this moment in time, and of the rich and varied and wonderful thing that is. Land is always under pressure, allotments are always under threat, and in this book are 31 reasons why they must be cherished. I hope you will enjoy reading it as much as we have enjoyed making it.

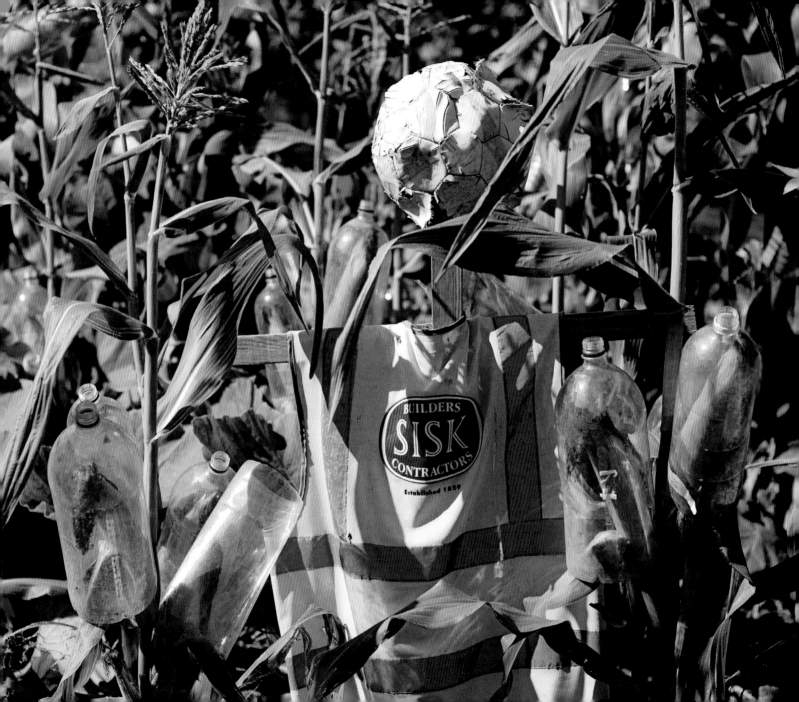

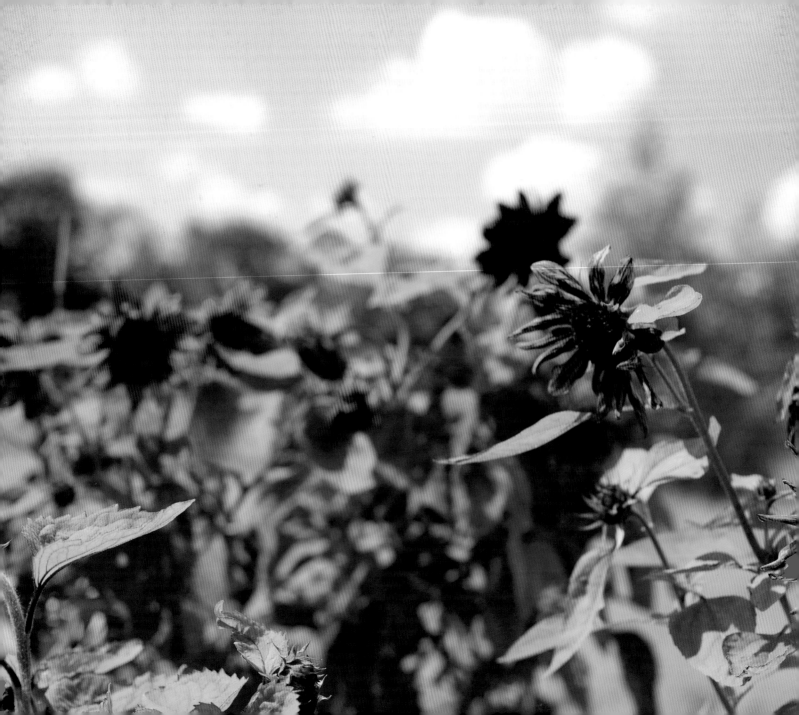

historic

It is easy to forget that allotments – now so acceptable and commonplace, even middle-class – were born from turmoil and hardship. The first English allotments sprang from the hard-fought battle over the 3 million hectares (7 million acres) of common land that were carved up and enclosed in the 1800s after a series of Enclosures Acts. The provision of allotment plots was some small compensation for the agricultural labourers who were denied their former rights to use the common land in a variety of ways.

There have always been elements of control surrounding allotment provision: the size of the allotment should not be so large that a family could make its living from it, or the result would be that the land-owning classes would lose their workers. Allotments were also seen as a way of keeping men out of the alehouses and on the straight and narrow.

Landowners and big employers have often provided plots to their tenant farmers and employees, but this could be seen as a way of assuaging working-class anger over the injustices of land division and keeping workers on side. The provision of plots has served the landowners' and employers' interests as much as the interests of the allotment holders.

By some miracle, the first allotment site in England is still in existence, as are many other historic and long-established sites. In this chapter there are examples of sites that have been around since the early days of allotment provision, as well as fishermen's and railway workers' plots, and a far earlier surviving floating market garden in northern France. These examples give us a backward glimpse into the origins of the allotment movement.

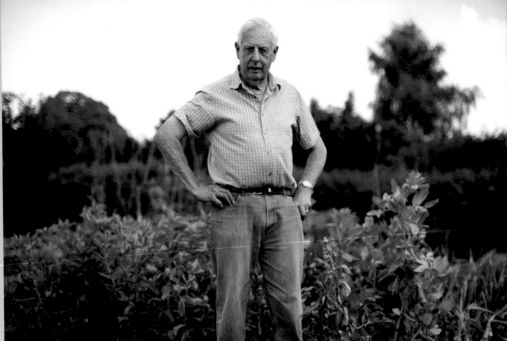

keeping with tradition

Arthur Scott is the oldest plot-holder on the oldest allotment in the UK – Great Somerford Free Gardens in Wiltshire. Aged 79, Arthur has worked his own plot for 60 years but, as a child, he also helped his father on his plot at Great Somerford, just as his father had helped his grandfather.

Great Somerford's allotments – and in fact, the vast majority of the sites and plots in this book – owe their existence to one Stephen Demainbray. Demainbray was a rector who took up his post in 1799, a precarious time for the rural poor. Most lived in small, cramped, poorly built houses on scraps of common land. Already barely surviving, these people suffered a series of failed harvests that made food and work unreliable.

At this time, the whole of England was covered in vast tracts of common land, which acted as a safety net for the rural poor. They could gather fuel there, trap rabbits, forage for berries and graze their animals. But a government plan was afoot. In the early 1800s, a series of Enclosures Acts carved up this land and gave it to local landowners and members of the aristocracy.

Demainbray recognised the devastating impact this would have on his parishioners and knew that, illiterate and powerless as they were, few would understand the implication of the Acts or be able to do anything about them even if they did understand. He fought to secure land for the parishioners of Great Somerford and in 1809 was successful in obtaining 3 ¼ hectares (eight acres) in perpetuity for them. He went on to campaign for allotment provision for the rest of his long and active life.

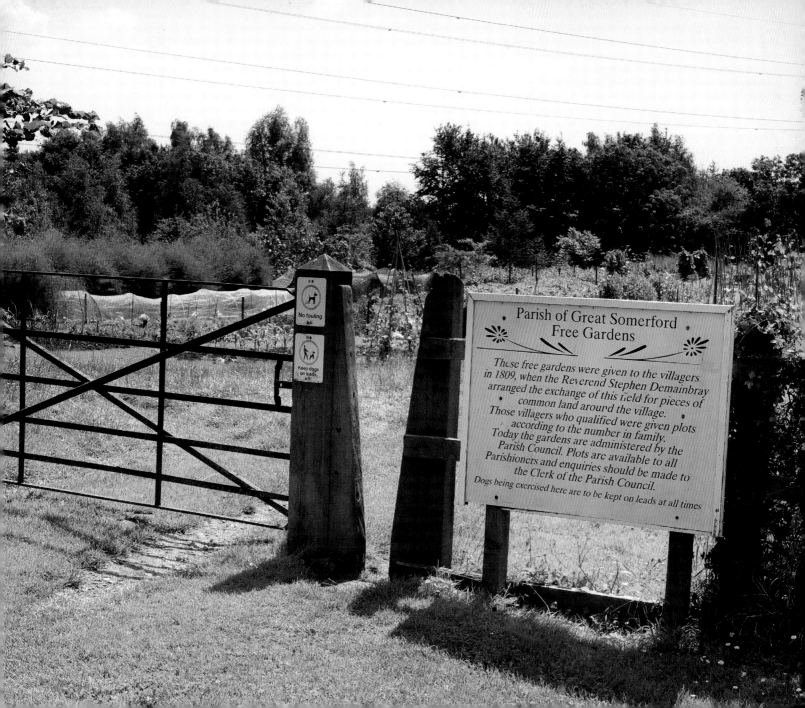

Parish of Great Somerford
Free Gardens

These free gardens were given to the villagers
in 1809, when the Reverend Stephen Demainbray
arranged the exchange of this field for pieces of
common land around the village.
Those villagers who qualified were given plots
according to the number in family.
Today the gardens are administered by the
Parish Council. Plots are available to all
Parishioners and enquiries should be made to
the Clerk of the Parish Council.
Dogs being exercised here are to be kept on leads at all times

No fouling

Keep dogs
on leads

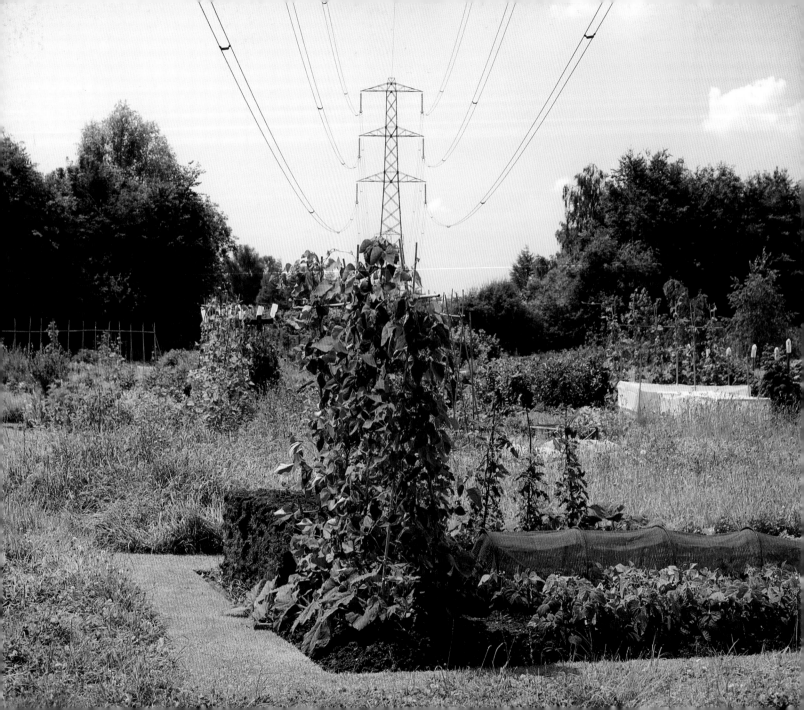

growing notes

Much of Arthur's childhood was spent on these allotments, but it was no place for childhood fun and games. 'The allotment was a place of work. You came here after school as part of your chores. When that was done you could go and play in the fields or on your bike.' Most plot-holders in the 1930s and 40s were farm labourers and 'everyone kept a pig. The small potatoes and vegetable scraps went to them, not into the compost.' It is striking that the plots here are so very carefully tended. Paths are neatly mowed, edges edged. Crops lean strongly towards the traditional: potatoes, onions, sweetcorn, strawberries, all perfectly grown. There is barely a weed to be found. 'It's such a shame these days; people take on a plot, then let it get into a muddle,' says Arthur, sighing. I look around, baffled. Arthur has no seat in which to rest and admire his work: 'If I sat down I'd quickly see "that wants doing" and I'd be up again. So why would I need a seat?'

There are good reasons for the strong work ethos here. Jill Shearer, author of *The Poor Man's Best Friend: The Story of the Great Somerford Allotments*, reports that on being asked why the plots were so successful, Demainbray replied: 'The allotments are cultivated in such perfection that, I venture to say, it is almost a disgrace to the farmers' cultivation; they [the allotments] are beautifully cultivated, and never fail.' Maybe the comparison between the way the allotments and the farms were worked meant little to the farmers and landowners, but it meant a lot to the allotment holders. Great Somerford encapsulated a radical and liberating idea. No wonder the allotment holders keep their plots neat.

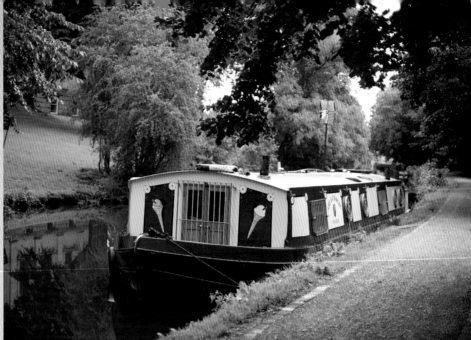

model village, model allotmenting

Saltaire is a model village near Bradford, founded in 1851 by the industrialist Sir Titus Salt to house both his mills and his workers. Like other model villages of the era, such as George Cadbury's Bournville and the Lever brothers' Port Sunlight, Saltaire's purpose was broadly philanthropic – to provide an alternative to slum living, in this case in Bradford. There was often a paternalistic whiff to these model villages (no pubs were allowed in Bournville, for instance), but they provided high-quality housing and access to amenities at a time when such things were shockingly rare. In Saltaire, such amenities meant schools, a library and reading room, a concert hall, a park, a gymnasium and allotments, all set among striking and handsome architecture.

The village's two allotment sites lie at the very centre of Saltaire, reflecting the importance placed on the morally upstanding activity of allotment gardening. In those days, allotments were seen as a way of keeping the working man on the straight and narrow. In *The Story of Gardening*, Martin Hoyles quotes *The Penny Magazine* of 1845: 'The objective of making these allotments is moral rather than economic; the cultivation of a few flowers is a pleasing occupation and has a tendency to keep a man at home and from the ale house.' One of the village's sites stands directly opposite Salt's village mill, while the other runs alongside the Leeds–Liverpool Canal behind the stunning Grade 1 listed United Reformed Church – a good reminder not to drop into the pub after you have harvested your carrots.

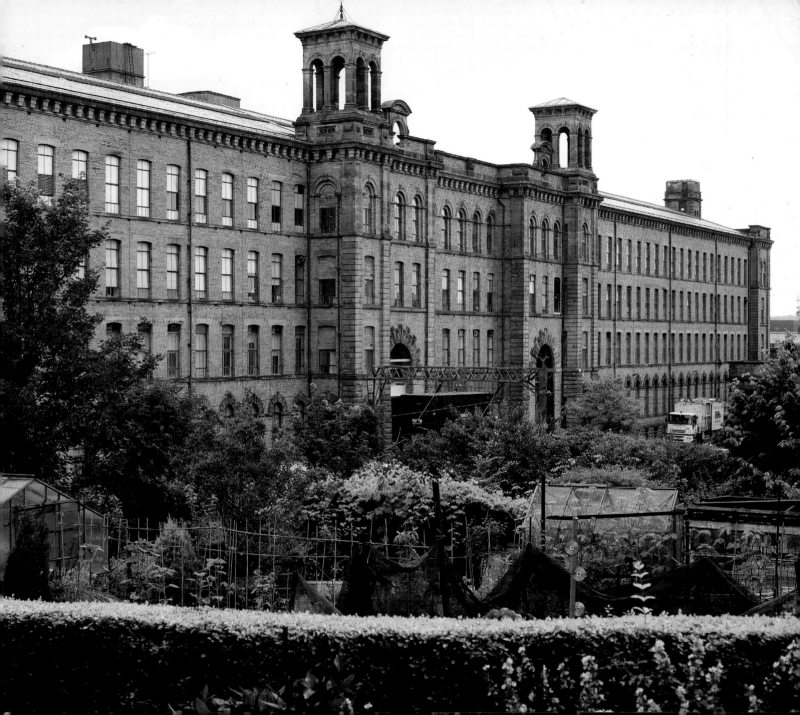

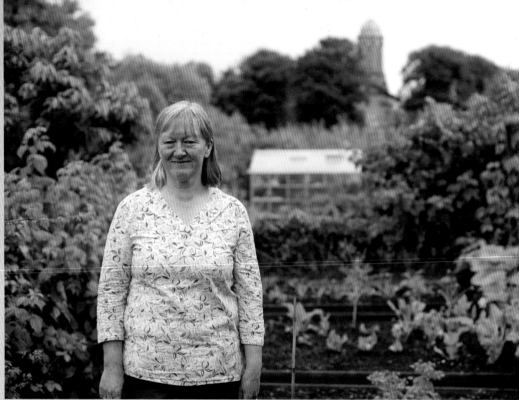

growing notes

Alison Cook has had a plot at Saltaire's Canalside site for ten years. 'The typical Saltaire homes had very small gardens, so the allotment sites have always been considered important and have usually been oversubscribed.'

Saltaire has just 26 plots and there are 36 people currently on the waiting list. Canalside is a privately run site owned by the property trust that owns the village. This arrangement gives those helping to run Canalside – such as Alison – a fair amount of freedom. 'We've started to divide up the plots so that people can have a go on a smaller one and move on to a full-sized one if they do well. We're a meritocracy: you work hard, you get a plot,' she says. Sir Titus would have been proud.

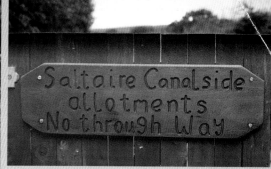

Saltaire has been designated a World Heritage Site by UNESCO and Canalside falls within its boundaries, making this as secure an allotment site as you could hope for. All the plots slope steeply down to the canal and several plot-holders have improved these tricky growing conditions by putting in terracing. Alison is one of them: the different levels of her plot are filled with fruit trees, vegetables and a great many herbs – fennel, lavender, clary sage (*Salvia sclarea*) – which she uses to make her own soaps and creams. Alison loves the site and the village and is deeply involved in the many community activities that – unsurprisingly – still go on in a place born out of altruism. 'We're all just grateful to be able to be a little part of this wonderful place, for a while,' she says, before packing up her tools and heading off to morris dancing.

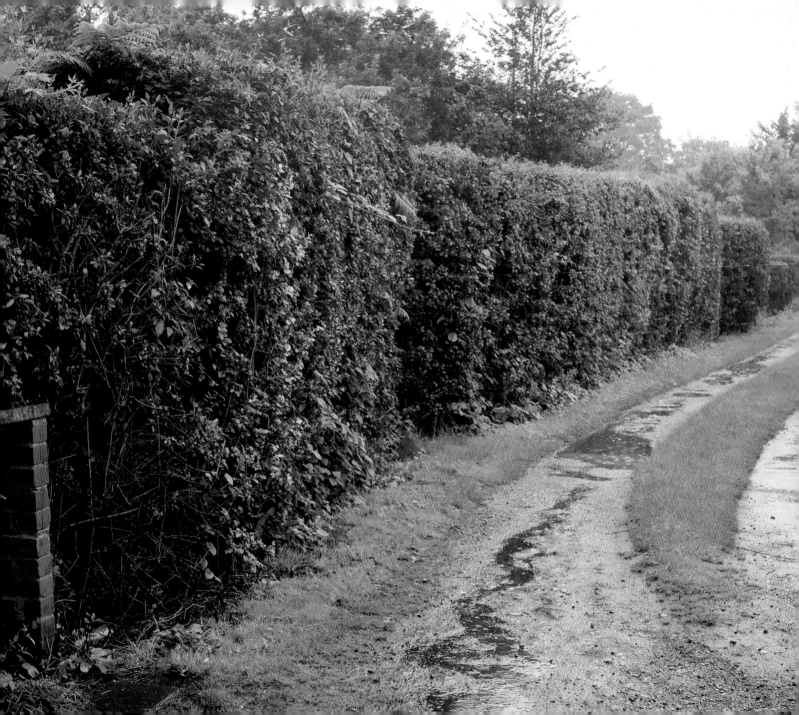

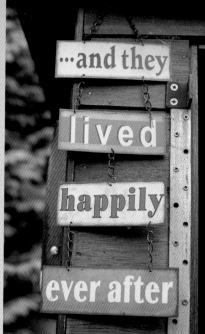

...and they lived happily ever after

up-to-date victorian gentility

Edgbaston Guinea Gardens were always a step up from your average allotment. They were created for genteel use by the skilled working class or lower middle classes, and 'garden' rather than 'allotment' was the operative word. Families would spend time here on their weekends away from the hustle of industrial Birmingham, going so far as to sleep in the red brick or wooden outhouses, which were fully equipped with stoves.

A central driveway, densely hedged all along each side, runs between the plots. It is a country lane dropped into the centre of Birmingham. But there is no hope of peeking in through the dense growth. Instead, every now and then you come to a locked wooden door in the hedge, each of which leads to one of the 80 secret gardens that line the lane.

Ali Abdulla has had a garden of his own here since 2008. An asylum seeker from Kurdistan, Ali has found a warm welcome among the allotment holders. 'When you talk at home about the English, people are scared, so I didn't want to come here but I had to. It was too dangerous in Kurdistan, but here I found the opposite of what I expected. People have been kind to me.'

Ali has become one of the most active and community-minded gardeners on the site, helping with hedge-cutting and any other jobs that need doing. He also has one of the most beautiful plots: it is pristinely kept and colourful, and he has won many awards for it over the years, including the Birmingham-wide 'Best Newcomer' award in 2008. 'I study English at college now,' he says, 'but here people chat, chat, chat. This is my real college.'

growing notes

Ali has certainly maintained the Edgbaston Guinea Gardens' tradition. His plot has perfectly mown grass surrounding a number of central flowerbeds. One is packed full of dahlias, while others are filled with herbaceous flowers – eryngium, phlox, leucanthemum and crocosmia. There is also a shade garden brimming with rodgersias, ferns and hostas, as well as a small pond with waterlilies.

There are also plenty of edibles here, such as a grape vine in the greenhouse and one of the heritage apple trees that are dotted around the Guinea Gardens, but this is primarily a beautiful garden for Ali to spend time in.

He had many experiences growing edibles in Kurdistan, but they were not happy ones. 'I grew up on a farm full of grapes, chickpeas, rice, walnuts, figs and tomatoes, but it was no fun. You had to work like an animal in the heat and I hated it. Here I can do what I want. There's nobody to tell me what to do.'

The thick hedges that divide the plots from the driveway also divide the plots from each other. They hide each gardener away from his neighbour and make each garden a private sanctuary, from which the gardeners can emerge in their own time. Ali has found a refuge here from his troubled earlier life and has made it a place of great beauty.

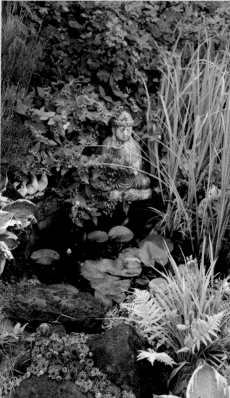

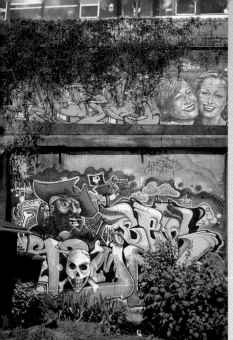

vegetables among the graffiti

There can be few more bustling spots than Sophie Laporte's *jardin familial*, or allotment. Hers is one of 14 plots sandwiched between a train line and a tram line at Belvédère de Suresnes. The plots sit on the commuter run into La Défense, Paris's financial district, the skyscrapers of which loom in the near distance. The wall behind her plot is covered in ever-changing graffiti and a constant stream of commuters passes her garden gate. Yet to Sophie (the head teacher of a local school) this is a little piece of paradise. 'There's no stress here,' she says. 'This is my place.'

Allotments are rare in France (you could argue that they had a real revolution in 1789–99, so there was no need), but these plots were originally the gardens of the railway employees. The plots slowly fell out of use and became wasteland until, in 2009, they were reinstated by the local *mairie* (town hall); interested gardeners were allocated plots by lottery. This recent history partly accounts for the neat, uniform appearance of the plots: each has a fence of chestnut paling, a shed and its own small gate with the name of a crop painted on it – *concombre* (cucumber), *échalotte* (shallot), *mâche* (lamb's lettuce), *lentille* (lentil) and Sophie's own *ail* (garlic).

Sophie loves to meet the passing commuters who lean on her fence to chat for a few minutes on their way to work. 'I'm happy to offer them some strawberries or radishes or flowers. People are interested. We're a little breath of fresh air for the people who go to work in La Défense.'

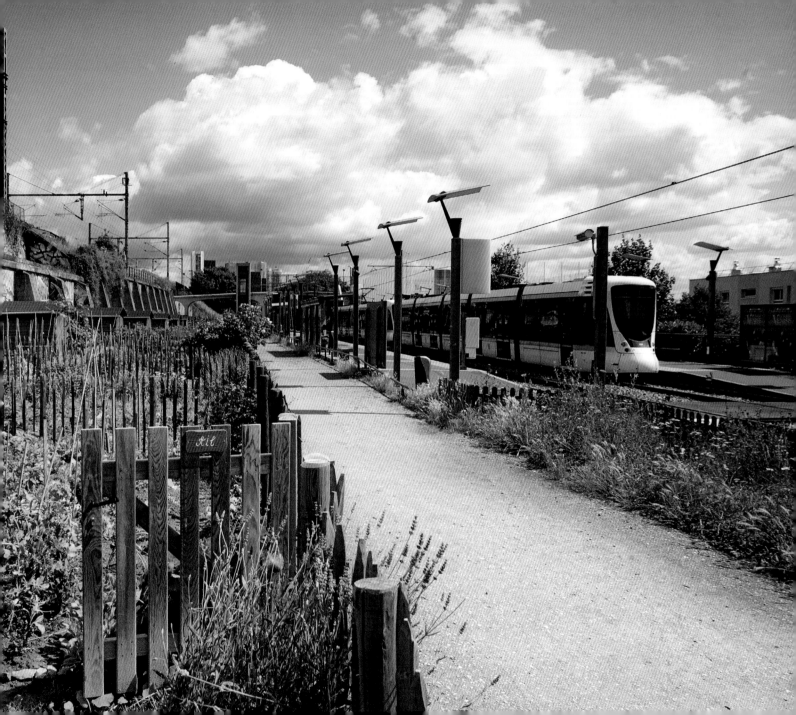

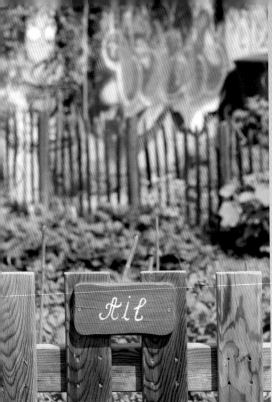
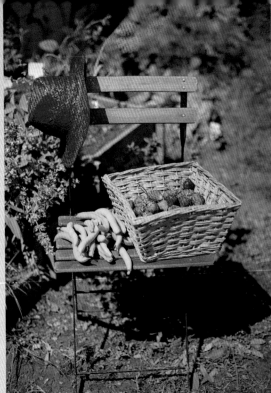

growing notes

Strawberries are Sophie's favourite crop. 'I'm the strawberry queen,' she says, as she picks a vast basketful from her patch of 'Maestro' strawberries. These fruit twice a year, keeping her, her allotment neighbours and not a few commuters in big, sweet, fragrant strawberries.

In accordance with the rules of the site, the majority of Sophie's plot is given over to vegetables such as lettuces, potatoes, beets, green beans, spinach, onions and her garden's namesake, garlic, as well as plenty of herbs.

On Sophie's plot, as on all the others, the tomatoes are supported by twirling, silvery stakes. Such uniformity smacks of the *mairie*, but no: 'There's only one gardening shop here,' says Sophie, 'and that happens to be the plant support they sell.'

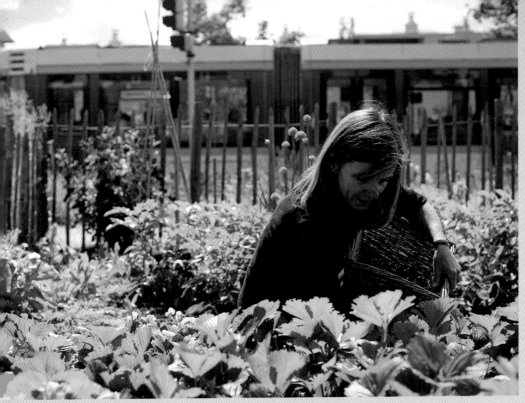

Sophie has found that the crops she grows have changed the way she cooks. 'I love to cook, but I cook differently since I've had my garden. I now cook more simply and as naturally as possible, with less sauce and fat. The vegetables are so good that there's no need to do anything sophisticated with them.'

Sophie also loves to grow flowers, but doesn't go down the traditional allotment route of growing flowers for cutting, instead choosing blooms such as pansies and pelargoniums. 'I like to see different colours in the garden,' she says.

Likewise she has a soft spot for the graffiti that adorn the railway embankment behind the plots. 'The graffiti were here before the gardeners. We've got no say in them. They change, appear and disappear, but all without any damage to the gardens. They're part of the place and help to give it its identity.'

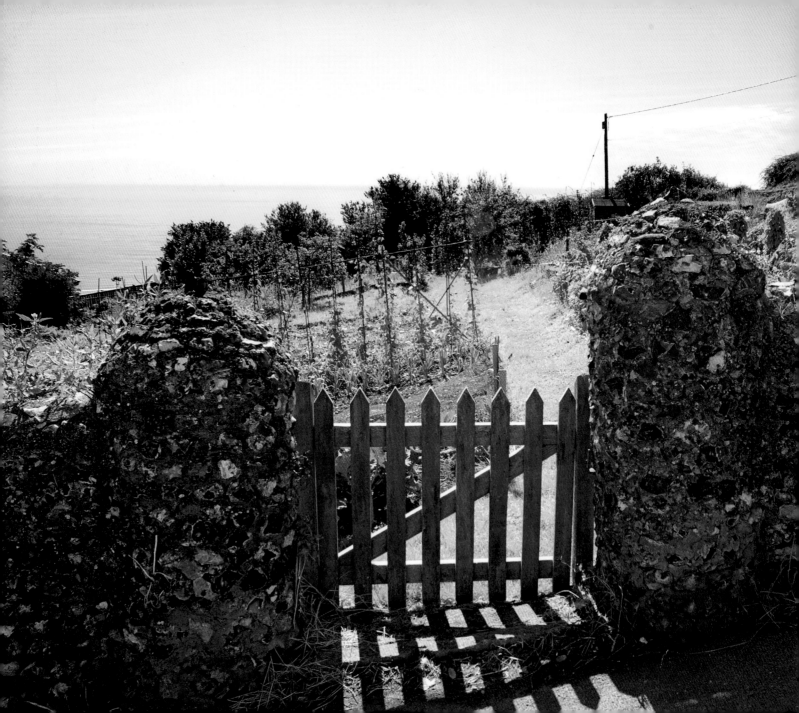

fisherman's cliff-top perch

'All this belongs to the Clinton Devon Estates,' says Ailsa Westlake, gesturing to the steep cliff-top allotments, where she and her husband Percy have gardened for 50 years. 'The whole village once belonged,' she goes on.

The thin strip of allotments that almost overhang the cliff once went hand in hand with the row of fishermen's cottages that back onto them. 'The cottages have tiny gardens, so each also had its own allotment. That way the fishermen would have a source of fresh vegetables.'

A few of the cottages at the bottom of the sloping site have no garden at all, so their owners are allowed to use their plots for drying washing as well as growing vegetables. Vests and pants are not welcome on the rest of the site.

Though Ailsa and Percy live in one of the fishermen's cottages (Percy was born at number 7 and they now live at number 11), the connection between the cottages and the plots has largely been lost. Most of the cottages are now privately owned and plot-holders come from elsewhere in the village and beyond. There is still one fisherman gardening on the site, though, as evidenced by the brightly coloured marine rope strung between two posts to support his raspberries, and some rather excellent knotting.

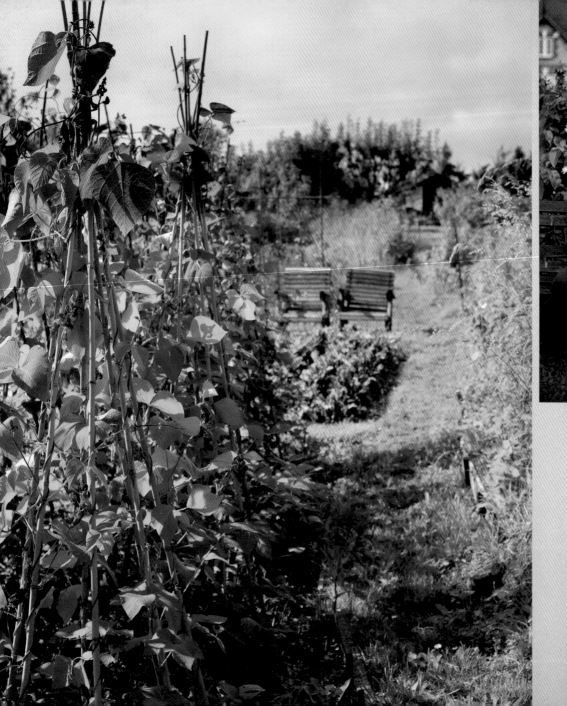

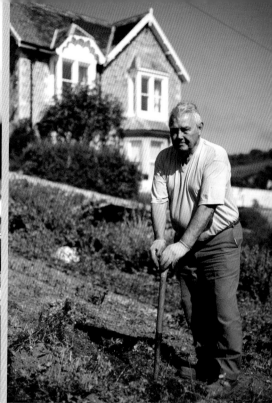

growing notes

'The growing conditions are wonderful here when the weather is good,' says Ailsa. Beer is set into a valley running down to the sea and does not suffer from the winds that hit other parts of the east Devon coast, so the vegetables grown here mostly bask in warm, sunny conditions and suffer few frosts. This means that crops which have a slow start elsewhere do particularly well; Ailsa gets good, early new potatoes and broad beans. Mediterranean herbs such as sage, rosemary and thyme thrive as if they were growing on the very Mediterranean scrubland where they originated. But growing conditions are awful when the weather is bad. A 'blow' – the local word for a bad storm – can hit at any time, and I saw fruit trees that had been blasted by salt-laden winds at blossom time. They were devoid of fruit and the foliage on the seaward side was crinkled and brown.

The soil is all that you would imagine cliff-top soil to be: dig 30cm (1ft) down and you hit solid chalk. Combine this with a steep slope, and drainage can be extreme. The soil needs constant amelioration with organic matter to keep it moisture-retentive. Ailsa and Percy used to walk down to the beach to collect seaweed, but they are now more likely to use manure from the farms nearby belonging to their two sons. Ailsa remembers the time when the fishermen-gardeners would create ditches into which they would dig the fish guts and heads. It certainly improved soil fertility but the plots must have stunk to high heaven. These days the link to the sea is less corporeal but there's no escaping that glinting body of water just over the hedge.

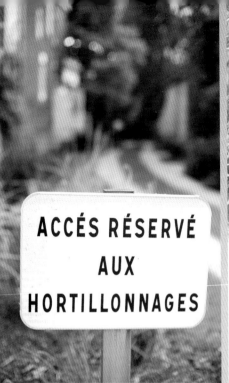

french floating garden

To reach the *hortillonnages*, or floating gardens, of Amiens you must venture down one of the many little alleyways that run between the houses on the eastern outskirts of the Picardy capital. At the end of your chosen alleyway you will find water, but only if you have a boat moored there will you gain access to the 25 hectares (62 acres) of watery vegetable gardens that were first created from the alluvial plains of the Somme around 2000 years ago. Swans and moorhens are your chief companions on this calm commute.

Vegetables have always been grown here and the gardens once supplied the whole of Amiens. Most of the *hortillonnages* are now gardened by weekenders and work in much the same way as allotments; many even have lawns and summerhouses. But the few remaining *hortillons*, as the market gardeners are called, still sell their produce every Saturday at the water market in the Saint-Leu district of Amiens. Jean Ducrocq is one of them. His is no hobby garden. He has worked his little patch of marooned soil every day for the past ten years, and loads up his boat to take to market each week.

'I grow lots of flowers – roses, cosmos, lilies and lupins. Later I'll have physalis and helenium. Herbs grow well, too, and so do potatoes, tomatoes and *petits pois*.' The soil is wonderfully fertile, which makes it possible to harvest some crops several times a year. Jean is rarely left wanting. 'A little fruit, some salad or some flowers – there's always something to take to market.'

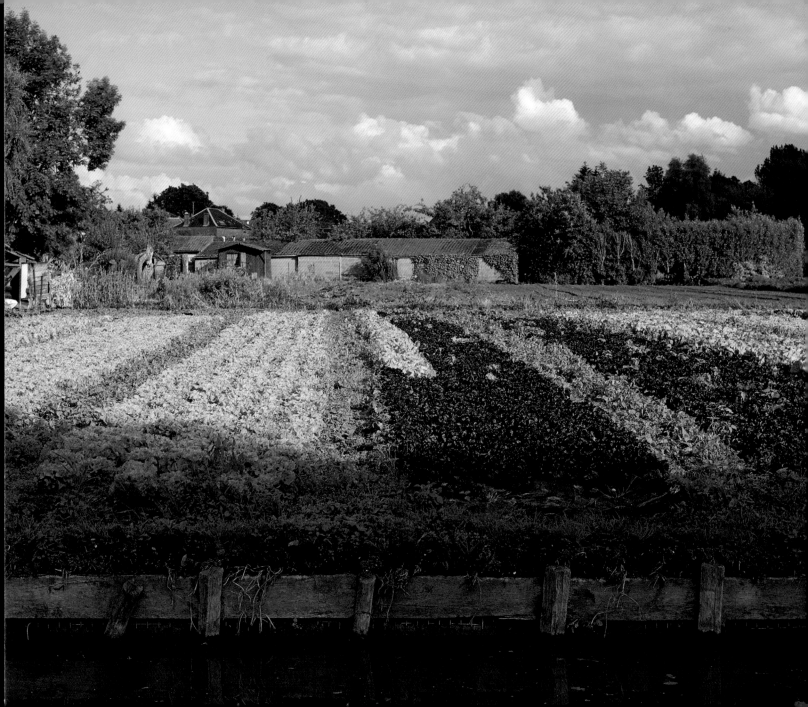

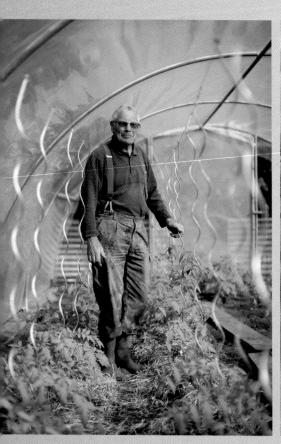

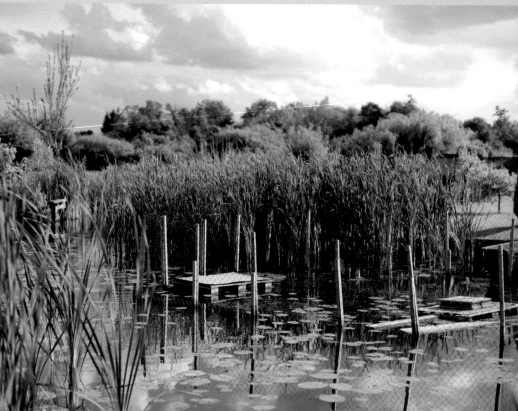

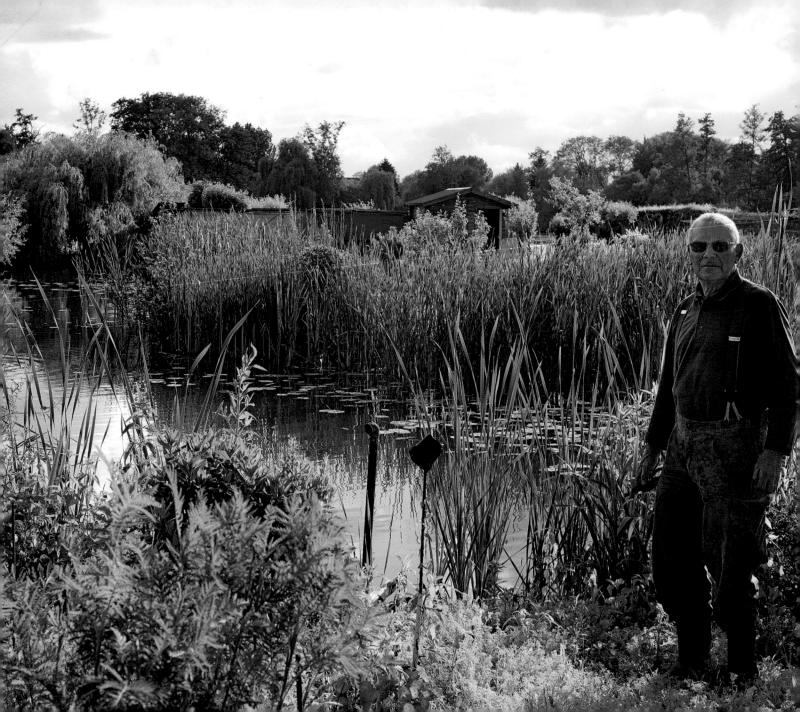

growing notes

There are several drawbacks to gardening on what is essentially an island. Jean has to transport everything by boat, including manure to make the soil more moisture-retentive. Unlikely as it seems, the soil – though wonderfully fertile – is extremely fast-draining. It is a mixture of alluvial silt, peat, chalk and gravel which has been dredged up from the waterways over the centuries. Despite all the water, watering is one of Jean's main jobs.

But, of course, the excess of water presents the major challenge to gardening here. Aside from occasional and devastating floods ('Everything was lost a few years ago,' says Jean. 'All the crops were washed away.'), the edges of the gardens must be constantly shored up against erosion. Most are supported by treated oak planks held in place with water-resistant acacia poles. Jean has also planted willow along his edges, to strengthen the banks. The waterways were traditionally dredged by hand to prevent them from silting up, but this work is now carried out by a mechanical dredger.

The soil on Jean's plot is deep enough to support a number of fruit trees, including cherries and several 'Mirabelle' plums. He paints the trunks with *onguent de Saint Fiacre* (St Fiacre being the French patron saint of gardeners), which is a traditional mix of lime and cow dung. 'It feeds the tree as well as protecting it from dehydration and scorching by the sun.' Jean's ghostly-looking orchards sit easily alongside the gently lapping water and the drifting swans in this ancient horticultural landscape.

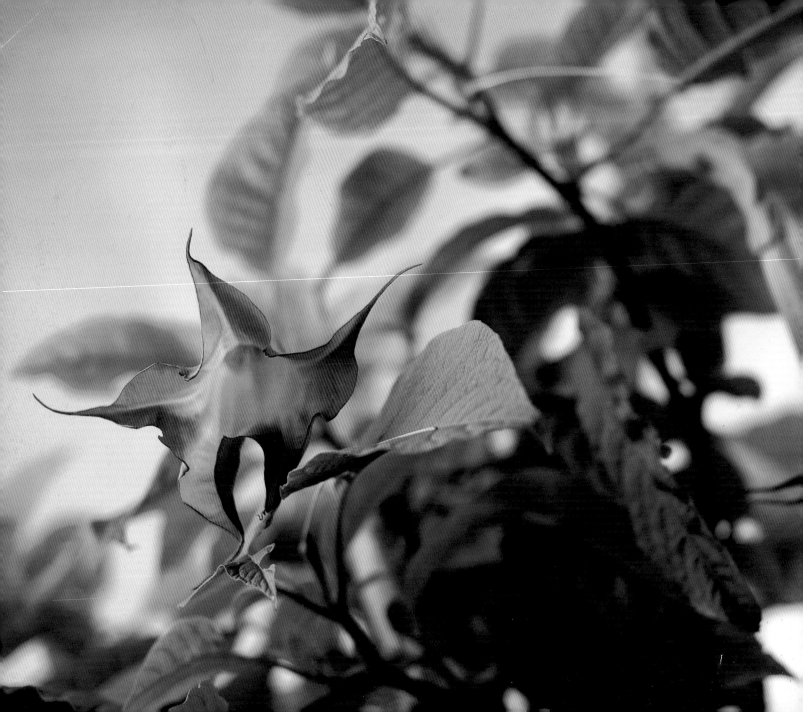

a feast of flowers

Sometimes it pays to bend the rules. Since allotments were originally set up to help provide food and sustenance for the allotment holders and their families, it is still written into many allotment constitutions that vegetables must prevail – or else. Though rows of cabbages and potatoes were never compulsory, growing something edible was. But as time has passed and the need for growing food has become less acute, flowers have crept in everywhere on allotments. It is a dull plot that does not contain a smattering of nasturtiums trailing languidly over the edges of a raised bed, or a few towering sunflowers.

There may well be sites where you can still be taken aside for a quiet word from an allotment committee member if you fill your plot entirely with flowers, but happily the plot-holders in this chapter garden under less dictatorial administrations. Whether their owners are growing for cutting and selling, for competition, to create a beautiful garden, or simply out of love of one type of flower, these allotment plots sing with colour – and the cabbage count is pretty low.

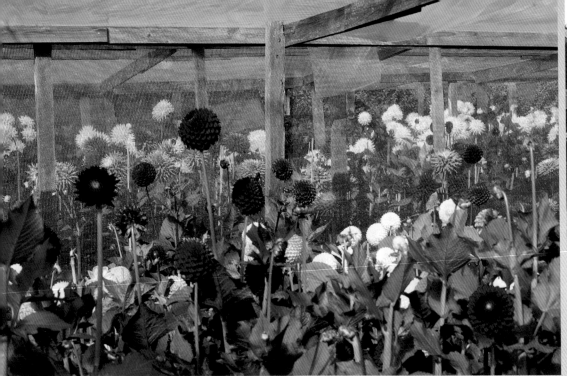
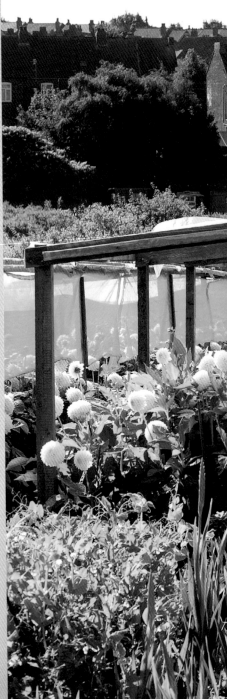

dahlia heaven

Brian Carter's plot at the top of a Birmingham hill is a sea of 'giant decs', 'cactuses' and 'little poms' – the affectionate half-names by which he calls his dahlias. He tends them with the gentle and expert touch of one who knows their whims. About to compete against 250 growers at the Birmingham Dahlia Society Show, Brian seeks out his perfect blooms, patiently passing over any marked ones and any that are not quite regulation size. He has plenty to choose from, so there is no need for panic. This is a man who knows how to win prizes.

This plot has been in Brian's family for 65 years; it was his father's before him. His father wasn't a dahlia man but was expert at the growing and exhibiting of flowers. 'He grew around 500 chrysanthemums and 700 gladiolis and we took them to all the shows.'

It isn't surprising that Brian ended up visiting a dahlia show out of sheer curiosity and thought: 'Hang on a minute, these are a bit special.' Each year he now grows 900 dahlias of 20 different varieties and always tries a few new varieties each year. 'I like them all and I grow every type. There can't be another plant on the planet with so much colour and so many different forms. They still get me.'

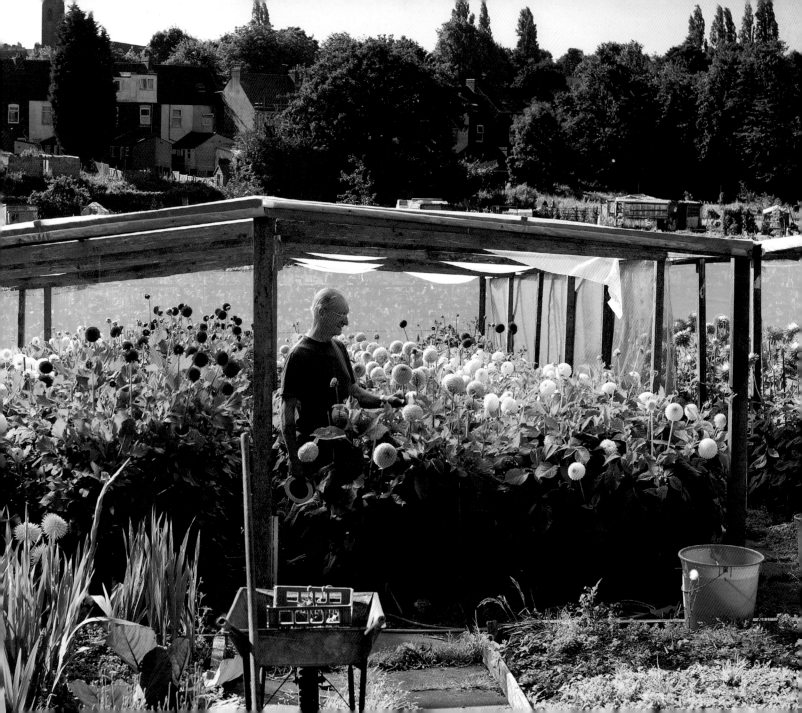

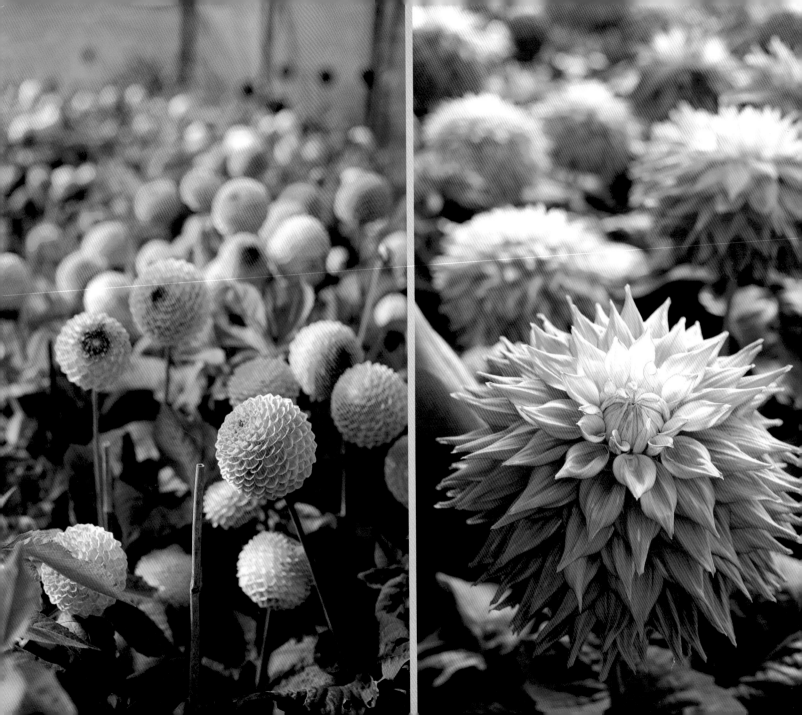

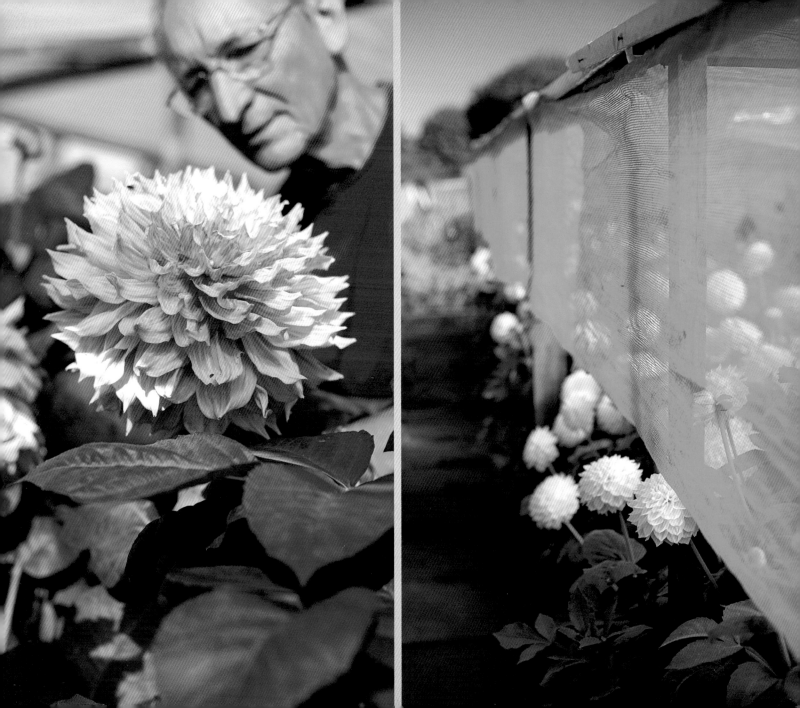

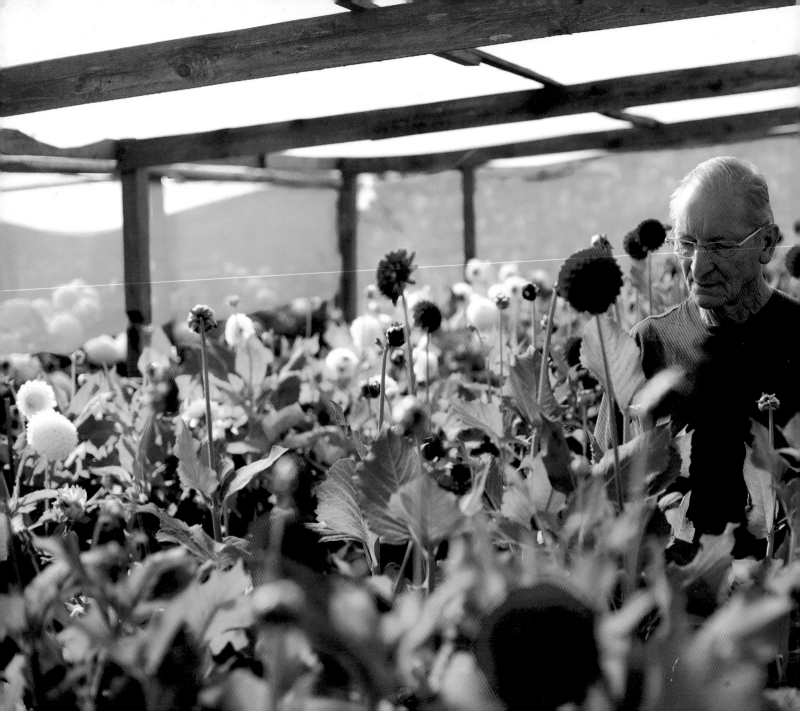

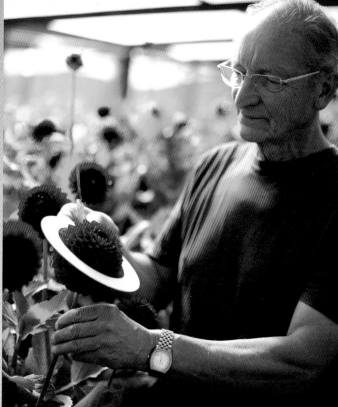

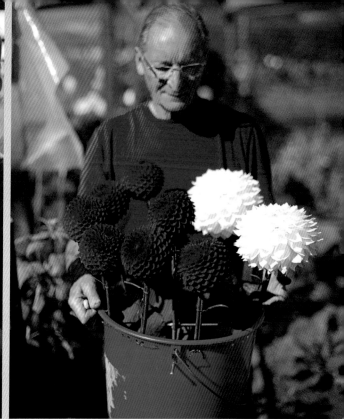

growing notes

'This is a 12-month job. The work never stops,' says Brian. The year begins just as the tubers are lifted at the end of the flowering season and before frost hits. 'I spread manure on the ground then, just as we've done for the past 65 years. The ground here is now 30cm (1ft) higher than the rest of the site.'

He gives many tubers away at this time of year but pots up several examples of each type and moves them to the greenhouses in his back garden. Come January, they are moved to the hot bed and started into growth, and from the new growth, Brian takes around 1500 cuttings. 'You get a more refined bloom from a new cutting than you do from a tuber, so I take them fresh each year.' He sells some to raise money for various dahlia societies or for his allotment site, but most are planted out once the danger of frosts has passed and are protected from marauding slugs by an armoury of slug pellets. Canes are pushed into the ground and string strung between them to keep the growing plants straight and true.

Brian's dahlia beds are surrounded by a wooden frame that will later support a rain cover. For most of the year the beds are left uncovered. 'If you cover them too early, the dahlias get drawn up and spindly.' As soon as the flowers start to show colour, the polythene covers go on to prevent the blooms from getting wet and to keep them pristine for when their moment comes. Finally, at 5am on show morning, along comes Brian, meticulously measuring the results of his labours with a set of judging rings, to help him decide which of his pompoms and giant decoratives will win him yet another gold.

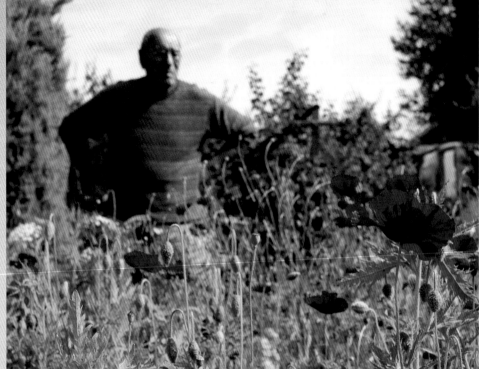

IT IS UTTERLY FORBIDDEN TO BE HALF-HEARTED ABOUT GARDENING. YOU HAVE GOT TO LOVE YOUR GARDEN WHETHER YOU LIKE IT OR NOT.

SELLAR-YEATMAN

portable tropical garden

It is lucky that Luigi Valducci is such a charming man. There is no way you could visit his Shrewsbury allotment site and not notice him. Luigi has three and a half plots but it feels like many more; he seems to have annexed whole sections of the site. Large printed signs fixed to walls announce the presence of his National Collection of *brugmansia*, but these are not the only signs. Luigi has a fondness for quotations and scatters them liberally around his plots, some printed, some handwritten on pieces of slate. They generally lean towards garden-related whimsy ('All my hurts my garden spade can heal' is just one example), but he also has a Latin corner and a Greek corner. 'People see these and they think, "This is a touch of class!"' he says proudly. Luigi is a big presence here.

The *brugmansia* collection came about after Luigi brought back three cuttings from a visit home to Rimini in Italy. One was white-flowered and one was orange, but it was the third – 'Pink Delight' – that stole his heart. 'I fell in love with these things,' he says. He now has 85 varieties of *brugmansia* and regularly entertains visitors who come to see them from all around the UK.

Such visitors, as well as fellow plot-holders, are also shown around his greenhouse filled with vast Italian tomatoes, and around his wildflower meadows, his orchard and his fully labelled chicory collection – complete with a treatise on why we should all eat more chicory. 'People come here. I want them to have fun and also to learn. I like to share.'

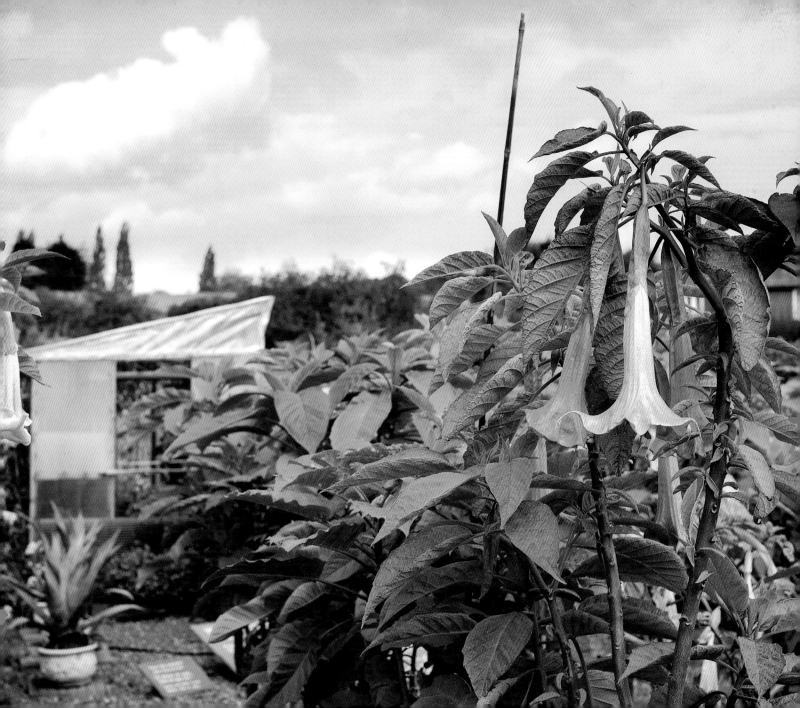

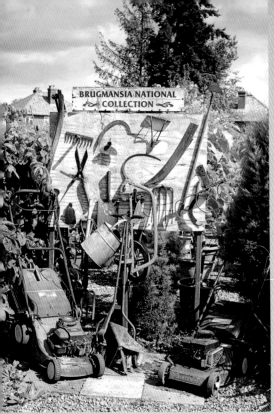

growing notes

Brugmansia are huge, tropical plants, commonly known as Angel's Trumpets because they bear big, pendulous, flared flowers that have an incredible scent throughout summer. They are hugely impressive and impossible to miss when they are in full flower.

But being entirely tender, *brugmansia* are far from easy to grow on an allotment. Luigi has to move every one of his great beasts – the larger specimens are in pots that are a good 40–50cm (16–20in) across – into a greenhouse he has built himself especially for the purpose. 'I use a sack truck and move them one at a time over the course of a week or so. It's a huge job. Sometimes my son takes pity on me and helps me out.'

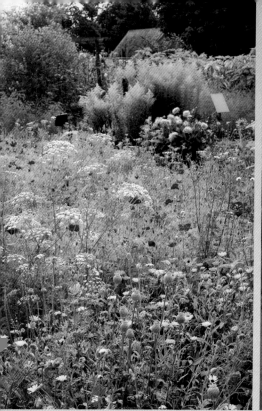 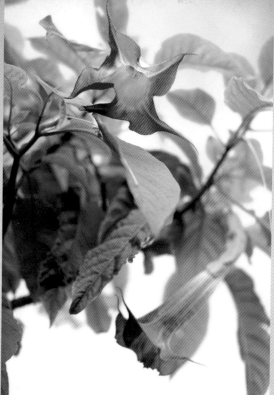 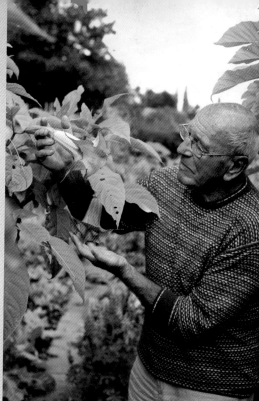

Luigi then has to heat the greenhouse throughout winter to keep frost at bay, so he sells a few cuttings to interested visitors to help with the not-inconsiderable heating costs. Cuttings are taken in September, put into jars of water and potted on as soon as they produce roots.

In spring, all the overwintered plants are cut back and returned to their outdoor home. *Brugmansia* are thirsty, greedy plants, so Luigi has set up a drip watering system and feeds them frequently with a balanced nitrogen and potassium fertiliser throughout the summer months, until the time comes to trundle them all back indoors again. 'I sometimes wish I'd started a collection of African violets,' says Luigi, laughing. Somehow that just doesn't seem quite his style.

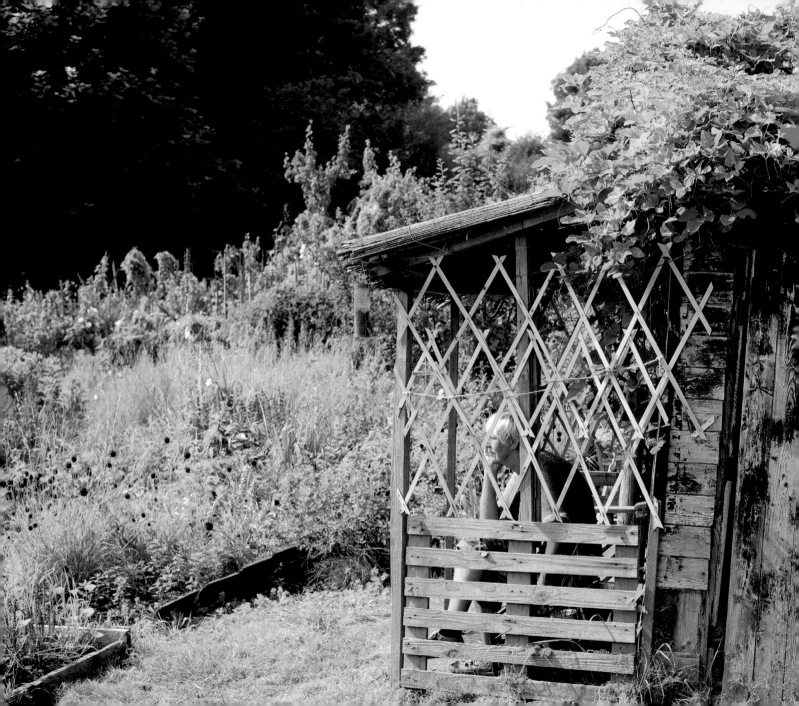

artist's cut-flower vision

The colours of Nell Nile's plot reflect those of her art – soft pink and coral, vibrant purple, egg-yolk yellow and raspberry red. Nell works in chalk pastel in this playful, Mexico-inspired palette of colours, and scatters the same shades throughout her flower-filled allotment in central Bristol.

She has not been able to resist adding little artistic touches to the plot. The wall of her arbour is patterned with rusted tools she found around the plot and a scrap sculpture doubles as a birdbath, but generally this place is not about work. 'I used to work here, in the shed, but now I use the plot as a place to get away from my art. It's like being on holiday here.'

Though she has a garden at home, it is shady and damp, and not at all suitable for the colourful flowers she loves. 'I'd always wanted a really good perennial border. I tried at home, but it was impossible.' So a large chunk of her plot is given over to perennials such as alchemilla, verbena, crocosmia and euphorbia, all of which are good for cutting.

Lucky locals can buy her bunches of mixed flowers – little pieces of art in themselves – from a nearby farm shop, and she also sells to a local ethical flower trader, who occasionally comes and picks for weddings and funerals. Despite the artistic touches, plot and art play very different roles in Nell's life. 'I work like a maniac, so my paintings come very fast. But here I've had to cultivate patience. This plot is good for me.'

growing notes

Many of Nell's favourite cut flowers are annuals, such as larkspur, salvias, zinnias, snapdragons and cosmos, which she sows early in the year on benches in her little polytunnel, or directly into the ground later on, when the danger of frost has passed. She also makes a great planting of bulbs, including tulips, alliums and gladioli, in autumn and spring. Only a very few require a long-term spot in the polytunnel: delicate lisianthus, for example, need shelter if they are to flower at all. The perennials mainly look after themselves, though weeds are a problem as there are so many in the soil. Nell grows organically and gets rid of them the old-fashioned way, where she can. 'An allotment isn't like a garden, though. A garden is controllable.'

'I first got the plot because I hate Sundays,' says Nell, 'and I thought this might be a good way to fill them. But now I find Sundays simply aren't enough.' Being self-employed, Nell can come to the allotment as and when it suits her. 'If it's sunny, I'm here three or four afternoons a week; if it's wet, not at all.'

Afternoons and early evenings are Nell's gardening times ('I don't do mornings, generally') and she likes to really immerse herself in the plot for long stretches at a time. She has installed a little mirror on the side of her shed to check herself over before she walks out of the allotment gate: 'So many times I've found myself walking up the main road with bits of twig or leaves in my hair. It's easy to forget that civilisation is still out there.'

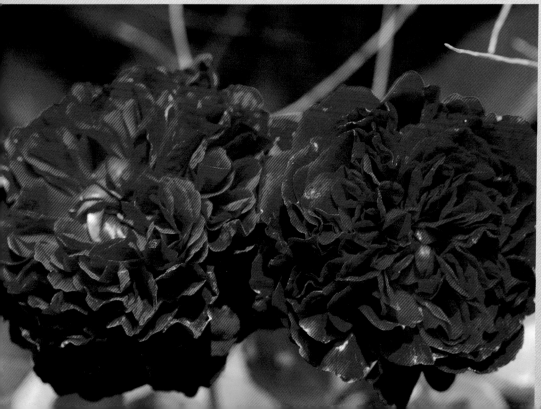

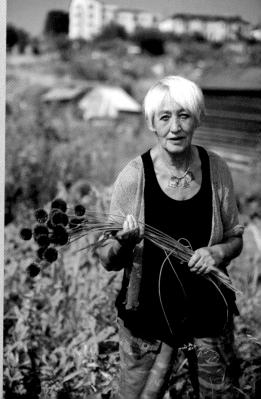

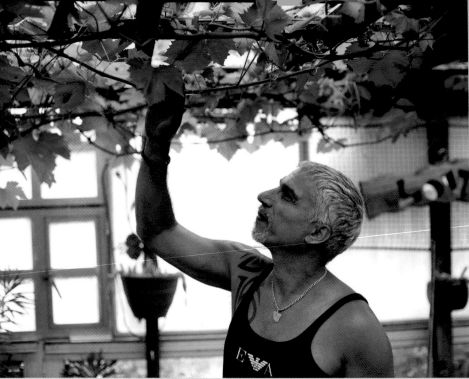

colourful london seclusion

Chris Achilleos's plot is on the far side of his allotment site, away from the gate. To reach it you walk past a large number of plots filled with rows of carrots, potatoes and dahlias. Then you arrive at Chris's door; it is painted bright blue, decorated with a mosaic numeral and locked. Beyond it lies the most unexpected allotment.

'I tried to create a garden on my original plot in the centre of the site, but it was exposed and too public,' says Chris. When this plot came up, tucked into a corner and alongside an old brick wall, he pounced on it. 'I didn't want it to be like an allotment. I wanted to create a little hidden world.' And he has. The allotment garden is entirely enclosed, with a thick growth of climbers clambering up its fences. Inside, the garden is extraordinary, filled to bursting with flowers, fruit and pieces of art. Just inside the door is a little covered area – a vine scrambles across the ceiling – containing borders of succulents and tables filled with seedlings. The next section of the garden is nothing but flowers – long-flowering salvias, daisy-like echinaceas, verbenas and a whole sea of lavender. 'I love Mediterranean-style gardens. I like the scent and the look of them,' says Chris.

In the third and final section of the garden he mixes edibles and ornamentals in an area encircling a white pergola. 'I love to have visitors in to show them around. They're always interested as it's so different here. But I also like the fact that I can properly close the world out. The fencing isn't just for the plants.'

growing notes

Chris wears his green fingers lightly. The plot, having been thickly overgrown when he took it on, was cleared in 'a couple of months of digging out the weeds every day. It was the only way to do it.'

Fencing off the plot and growing thick climbers over the fences has proved a bit of a masterstroke: it has created a warm, sheltered microclimate where his plants thrive, particularly the fruit. 'I've got more blackberries than I know what to do with. A neighbour comes and picks them and gives me some of the jam she makes.' His figs are vast, fully the size of his palm, and there are a lot of other fruit trees here, too, so Chris has trained several of them into a weeping form to keep them small.

But what Chris wants above all else is colour. He sows colourful annual climbers each spring, such as the *Ipomoea lobata*, or Spanish flag, that waves jauntily from the pergola at the centre of the garden. He also propagates lots of his flowering plants, including the colourful salvias that are found all around the garden, and to keep his flowers producing all summer long, he is generous with a high-potash feed.

But other than these jobs, this is a surprisingly low-maintenance garden. 'I cut back the herbaceous plants in autumn or spring, cut back the lavenders in late summer and mulch the fruit once a year in winter. Apart from that it's mainly harvesting.' All Chris's hard work and the excellent planning that went into setting up this magical allotment garden have truly paid off.

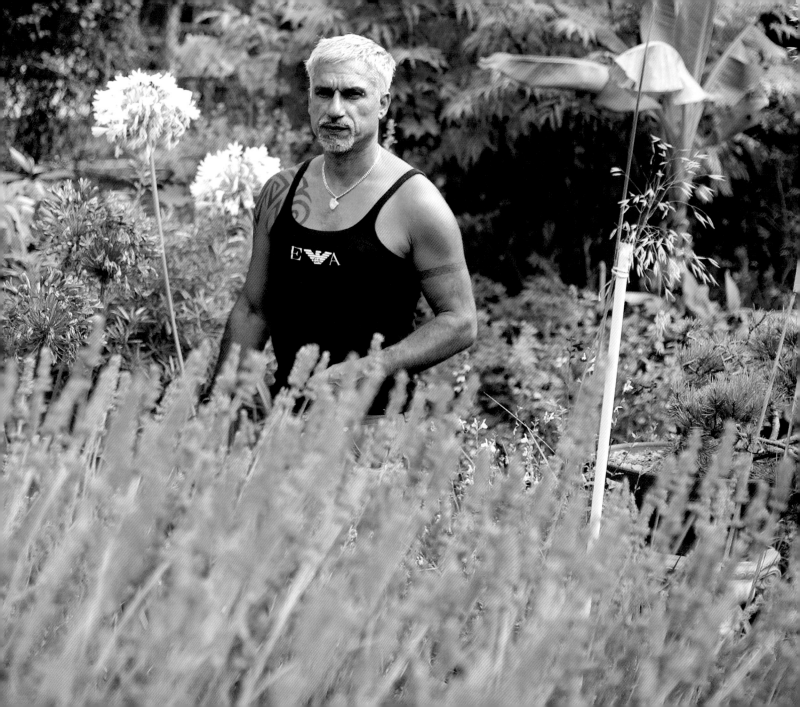

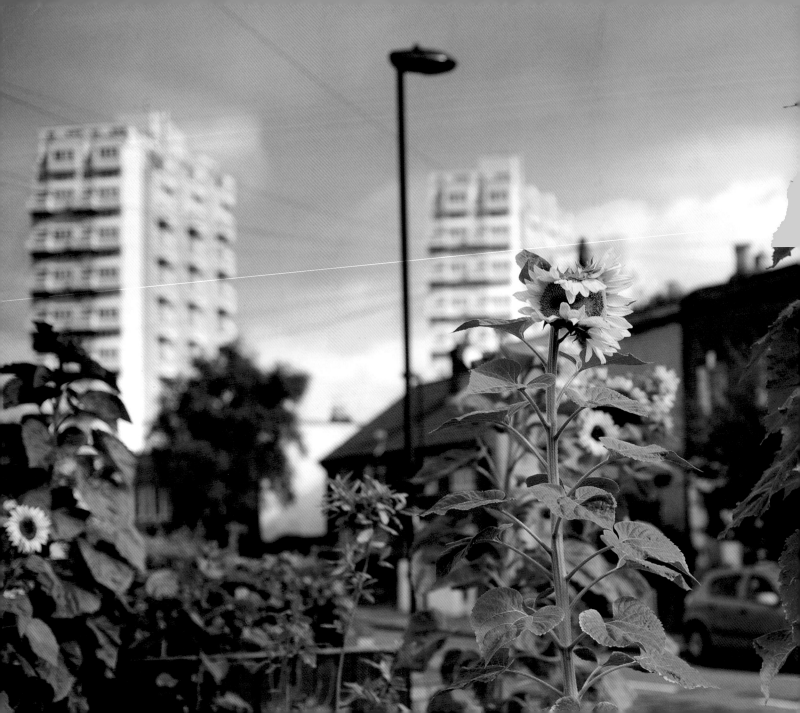

all for one

Growing food is a wonderful way of bringing people together. Working together and striving for some common goal – even if that is simply to sit and eat something own-grown together once a week – is easier and more fun when you share the load with like-minded people. It is one of the reasons why there are now so many community gardens springing up on every piece of wasteland and abandoned allotment corner.

Community growing projects often emerge from threat: a piece of land about to be built on or an old orchard about to be grubbed up. In these cases, the clamour of many voices is always stronger than one lone voice, and a number of hands is needed to turn the potential into the reality. Most of these community projects have a higher aim beyond the simple growing of food: creating sustainability and resilience in the face of an uncertain future, greening the cities or the passing on of growing skills to children and young people. Organising and keeping people happy while meeting the needs of a garden is a tricky juggling act, and many fall by the wayside. The projects in this chapter have found ways of meeting that challenge and provide some very different blueprints for growing food cooperatively.

food resilience in a welsh village

In 2008 a large piece of pasture and woodland came up for sale right next door to the small village of Knucklas in Powys, Wales. 'It seemed such an opportunity,' says Kevin Jones. 'It's the sort of site that should be publicly accessible. It's right on the edge of the village and contains woodland and the old ruined Knucklas Castle at the top of the hill. Three of us got together with the thought that this should belong to the village.'

Having to move quickly, this initial group put up the money themselves and bought the eight-and-a-half-hectare (21-acre) site at auction for £86,000. A community group was subsequently set up that now leases the land from the owners.

The aim was always to turn this into growing land for the community. 'A group of us had been talking about ways to make Knucklas more resilient and capable of producing its own food.' The allotments are just one part of the scheme. An orchard of 86 local varieties of apples and plums has been planted and there are plans to create a market garden to supply local businesses.

'There's a different feel to the village now,' says Kevin. 'It didn't have a particularly strong community feel before, but now there's a real sense of belonging. The plot-holders have a stall once a week outside the local pub, so the rest of the village is slowly being drawn in, too. It's all worked out exactly as we'd hoped.'

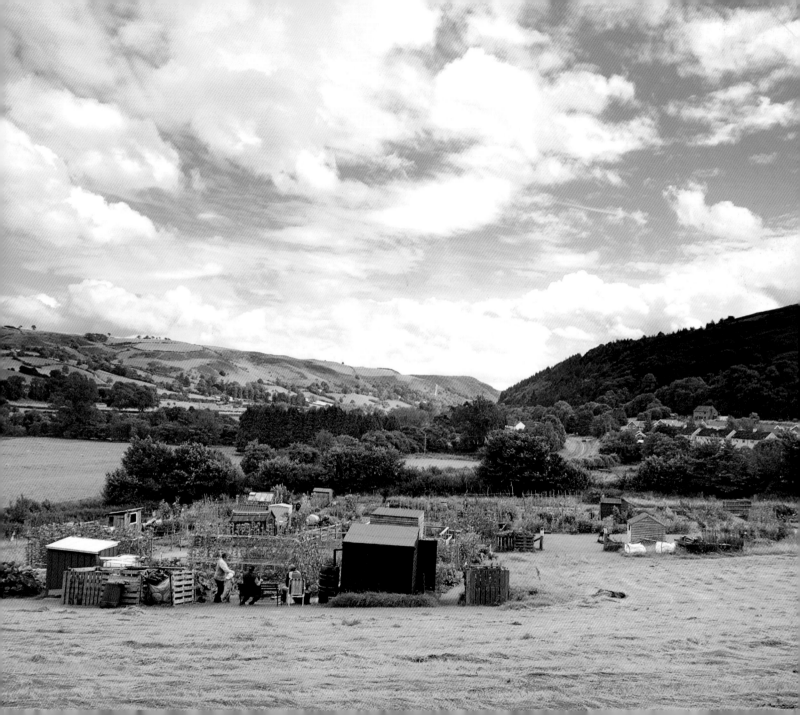

growing notes

One of the site's huge successes has been the children's garden, run by Siggy Haynes. 'We have a youth club every Saturday. About 12 children come regularly, but others drift in, too. They have a plot each and grow whatever they like. Even if they disappear after the first session, that's a seed planted in their head for the future.'

Siggy puts a huge amount of energy into the youth-club plots, but she's hoping to reap her reward. 'When I'm 80, I expect this lot to be turning up at my door with cabbages and carrots.'

Knucklas isn't an especially easy site for growing. The land slopes down to the west and offers a stunning view out towards Offa's Dyke, which runs along the ridge of the opposite hill. It is striking in looks but cold and windswept for plants and people alike. Cheeks are a wind-blown pink: raincoats *de rigueur*.

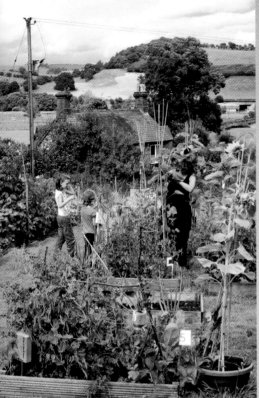
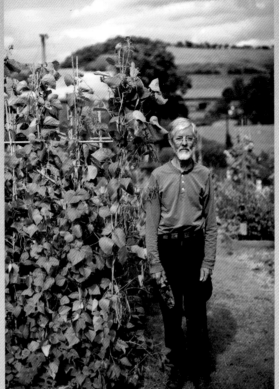

WELCOME ❀ **KNUCKLAS CASTLE** ❀ **COMMUNITY LAND PROJECT**

ORCHARD, ALLOTMENTS & PATH TO CASTLE HILL

The field was a natural meadow, had not been ploughed for years and is not especially fertile. But luckily, manure is not hard to come by in such a rural spot, and where the ground has been enriched, yields are great. 'We're learning all the time about how best to work this land,' says Ann Bywater, one of the newer allotment holders.

There is a sense of eager cooperation here at Knucklas: a couple of mowers have been donated and a notice reading: 'Please cut the grass paths when you can' appears to be all that is needed to keep said paths in pristine condition. Everyone seems determined to make this little utopia work.

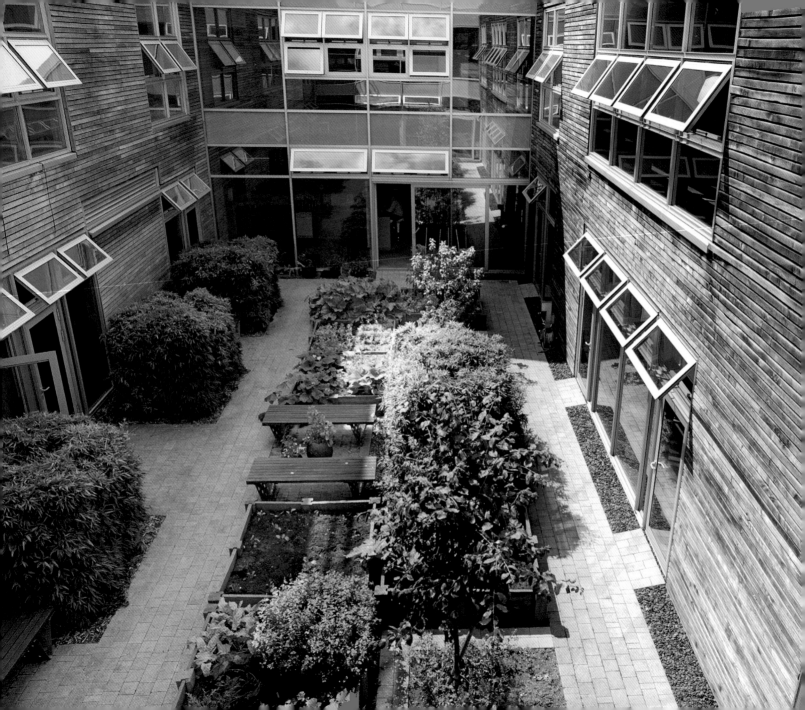

edible haven for office workers

The gardening club at Heelis, the National Trust's headquarters in Swindon, comprises a small group of Trust workers who keep the garden at its centre green and productive. 'We meet about once a month,' says Philip Osman, head gardener, 'and I think this is the secret behind the success of the garden.' The group discusses work to be done in the pocket-sized courtyard garden, goings-on in their own patches at home, and gardens and shows that they will visit together in the future.

The National Trust knows a thing or two about looking after volunteers. 'The Trust relies on its volunteers and has a huge respect for them,' says Anne Whiteside, 'so as members of staff, we don't mind doing our bit. Like most volunteers I get a huge sense of pride and achievement from it.'

The garden is at the heart of the headquarters' modern, purpose-built building. It is very different in design from most of the properties the Trust represents, but complementary in ethos. Sustainability has been woven into its fabric, with solar panels making it self-sufficient in power, and automatic ventilation controlling the temperature. The courtyard was designed as a light well, and as a place for office workers to enjoy outdoor meetings and lunches.

The garden also supplies the kitchen with food, though this has its hazards. 'We've had to teach the chefs how to harvest,' says Philip. 'Once one wanted some chives and dug up the entire plant. We were mortified. But now the chefs know more about where their food comes from, and understand how it grows. It's part of the function of the garden.'

growing notes

Being such a small area and so overlooked, the planting here needs to be intensive. 'Because of the building, the light levels are low and germination can be slow. We could have a lot of bare earth for a long time,' says Anne.

Instead, she sows seeds in plug-plant trays at home in her greenhouse, and brings them in ready to plant out. 'We plant a lot of salads: I have a production line of lettuces and sow a new batch once a month. They're colourful and cover the ground, and the kitchen can always use them.' She always includes varieties named after National Trust properties, such as the deep-red 'Nymans' lettuce and the mid-green 'Chartwell' cos lettuce.

Anne also sows lots of herbs for the kitchen and there are a couple of small apple trees and a large patch of rhubarb. In winter the beds are filled with hardy lettuces,

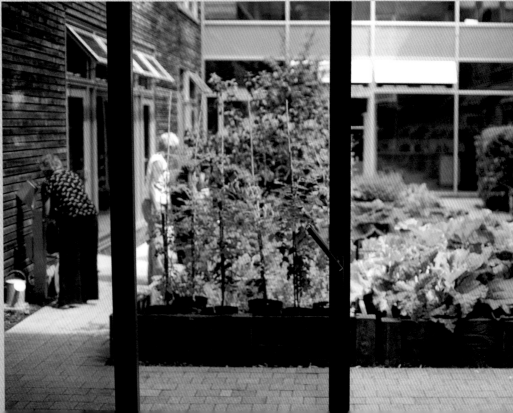

kale and chard. Flowers are not forgotten, either: Anne makes sure that there are always flowers such as marigolds and nasturtiums in summer, to keep the garden colourful.

The building is on the site of the former Great Western Railway works, and the soil was polluted, so everything has to be grown in raised beds, all the soil must be imported and the volunteers have to top up the beds with manure and compost in winter.

'This can cause a few problems,' admits Phillip. 'We've been yelled at by the office staff, but the rest of the time I think our efforts are pretty well appreciated by those whose work space overlooks the garden.'

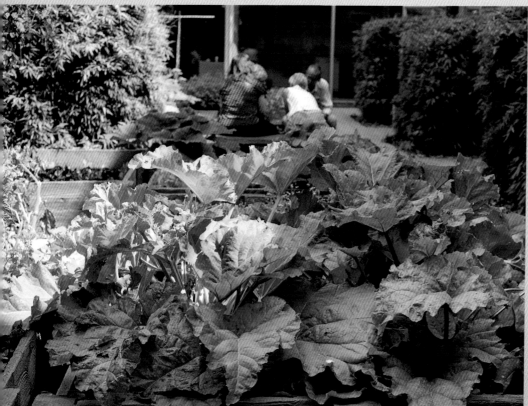

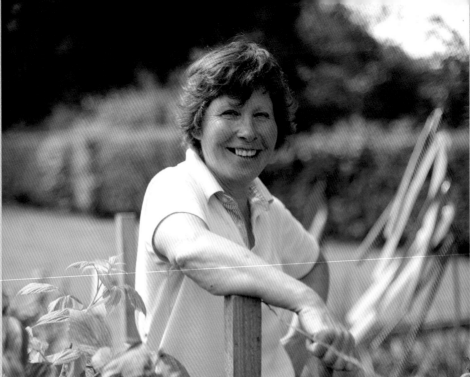

learning through gardening

Margaret Portus brims with energy and enthusiasm: she has to with 210 small gardeners under her care. Bradley Barton is one of the very few schools in the UK that have made gardening an integral part of the school week, and every single child in the school spends two hours a week with her. 'It's very different to a gardening club,' says Margaret, 'where a few kids get to take care of a small area. We have to find ways to get them all through here.'

This leads to some unusual horticultural decisions: the children sow, grow and compost hundreds of tomato seedlings, for instance. 'They're the perfect size for little hands to practise potting-on,' says Margaret. 'Many seedlings get snapped in half but we don't care. You learn far more by failing than by succeeding.'

Margaret is hot on the lessons that gardening can teach through the back door. 'We encourage the children to ask questions and to find their own answers. "Can seeds grow anywhere?" was a recent one. We tried sowing some on Lego bricks, in socks, in paint, on play dough …'

It is all immense fun but has a serious side. While visiting, I watched two seven-year-old boys – not the typical sort of child you would expect to love writing – plant out peas, and then voluntarily and lovingly label them in their own inimitable style: 'No buddy step on the peas!!!'

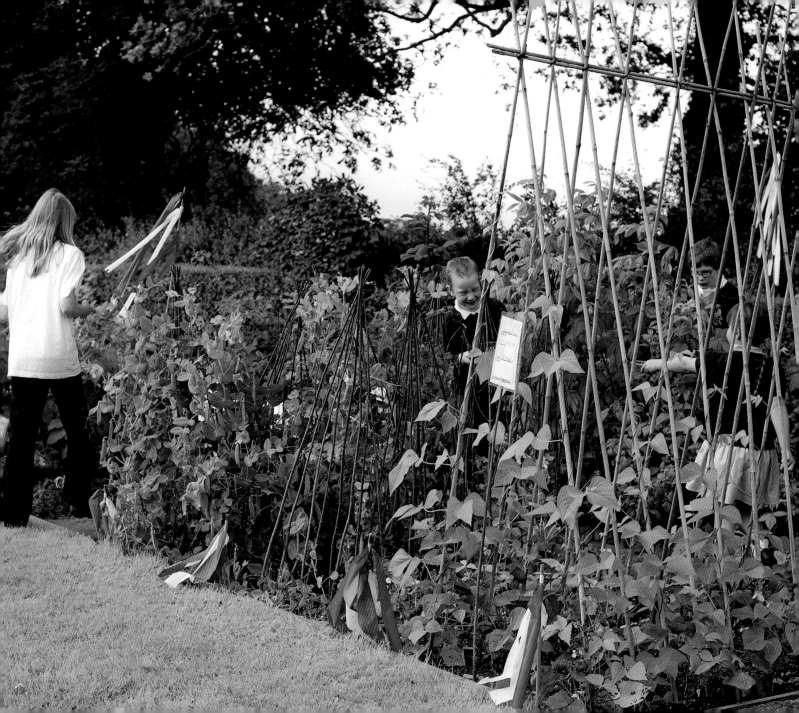

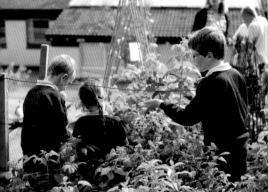

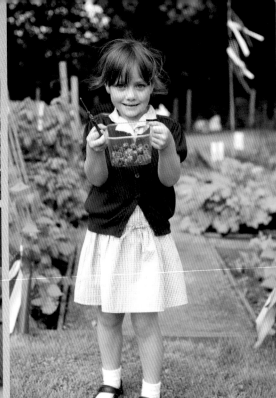

growing notes

'Children judge success in the garden in different ways to adults,' says Margaret. 'Maybe here, a tiny, miniature carrot will cause the most glee, or a vast rotting potato full of worms.' They grow broad beans every year, not because the children love to eat them – they are children, after all – but because they are great hosts for ladybird larvae, and there are few kids who aren't captivated when they see the way the primeval-looking larvae are transformed into ladybirds.

The main allotment has twelve 3m x 1.5m (10ft x 5ft) plots, each containing a different crop. Each year the children concentrate on one crop. 'They can't become experts on everything, but they can become experts on carrots.' So this year they are growing seven different types of carrot in different places, and eating them at all different stages of growth. They will know carrots all right.

School holidays that were originally designed to allow children to help their parents at sowing time (Easter) and harvest time (summer) are a particular challenge for school gardening clubs. 'We have to have a few tricks up our sleeves. We plant just before the summer holidays, so the crops are ready when we return at the end of the summer. But it isn't the most straightforward way of growing.'

In addition, every child gets a term each year to learn to cook the produce he or she has grown, turning it into chutneys and jams.

Margaret watches shy children who won't speak in class starting to ask questions and give other children direction; children who can't concentrate, completing tasks; and those who have never been allowed to get mucky, picking up worms. It is not about the produce. 'They grow plants,' she says, gesturing towards a group of children happily picking raspberries. 'I grow children.'

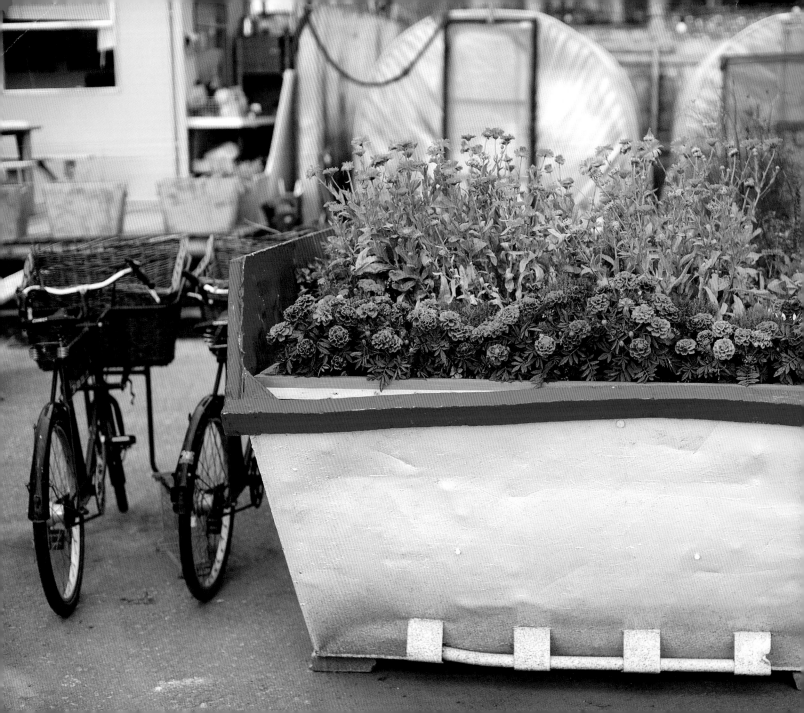

upcycled skip garden

At the centre of a major building site behind Kings Cross station in London, lies a community garden. 'It's not the sort of place people expect to find a garden,' admits Jane Riddiford, executive director of Global Generation, a charity dedicated to the joint aims of creating a sustainable future and providing opportunities for young people. 'I wanted to find out what happens when you put the community at the heart of big business.'

The Skip Garden is here not only with the permission of the building contractors, but with their active support. Land, materials, electricity and toilets are provided free and in return, the construction companies regularly send employees for 'lunch and learning' alongside the young local people who work on the garden. 'It means we're not outside the system, shouting about change, but at its centre, changing the culture', says Jane.

Global Generation's experience has all been positive. 'The construction guys come in and say, "we can learn a lot from you." There's real good will. Plus it's their chance to not be seen as big bad developers'.

Because of its location on a building site, it is important that the garden can be moved at a few days' notice, and in fact it has already moved twice. The man who makes this possible is Paul Richens, who designed the upcycled skips that act as giant raised beds. 'We should always use local vernacular materials and here that means building materials.'

So the raised beds and polytunnel have all been created using spare water pipes, scaffold netting and planks from the surrounding site. 'I'm averse to the idea that only idyllic country life can be sustainable,' says Paul. 'We have to work with what we have. We have to make cities wonderful.'

growing notes

The garden is housed in seven skips, each with its own purpose. One holds an orchard of trained dwarf apple trees, several are for annual crops such as beetroot, carrots and salad leaves (there being several skips allows crops to be rotated between them each year to prevent a build-up of soil diseases), one is a polytunnel filled with tomatoes underplanted with French marigolds (*Tagetes patula* – an example of companion planting – the marigolds emit a strong smell that helps keep aphids away from the tomatoes), another contains a herb garden, and a final skip is filled with wormeries and a comfrey feed bin. 'This is the "green engine" of the rest of the garden,' says Paul. 'It's the most important of the lot. Nothing works without the plant feed we generate here.' Paul has built steps at the end of each skip and into its centre, and inside, the raised beds are roughly at waist-height. The beds have been set up so that excess water is collected in guttering and fed back to a water butt. 'Water management is one of the main challenges for the future of gardening,' says Paul, 'so this garden has been designed from the start to use as little water as possible and to capture any runoff.'

The garden is cared for by Paul alongside the young local volunteers that the group calls 'global generators'. 'This place is about giving young people a tangible sense of a potential future' says Jane. 'We develop the young people's ability to talk as equals to business people and decision-makers, at the same time as teaching them gardening and beekeeping.'

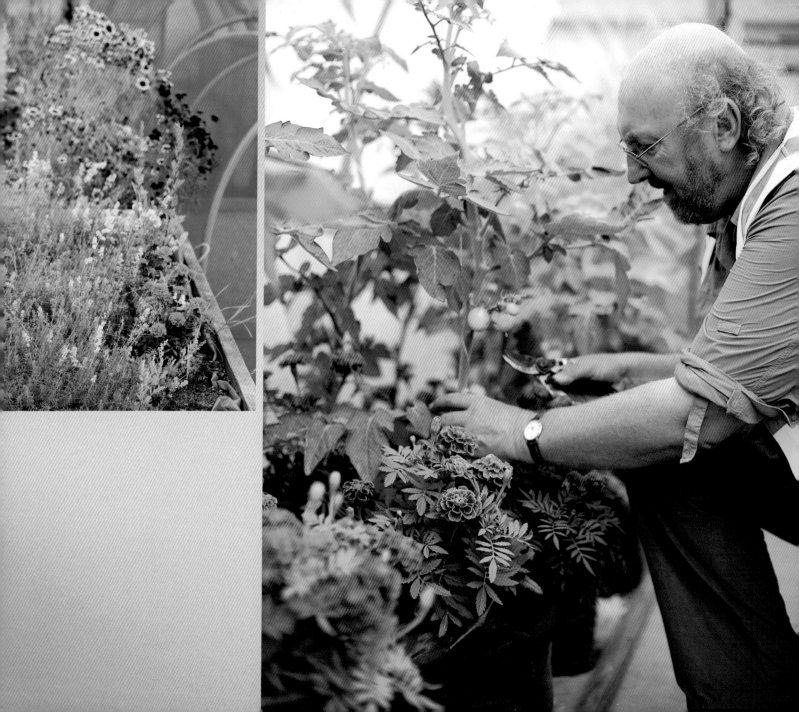

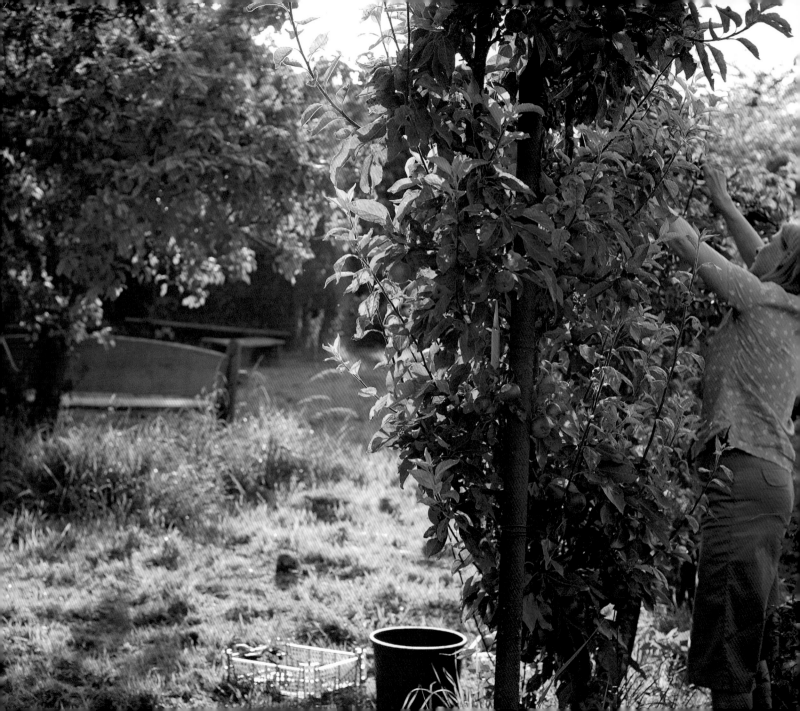

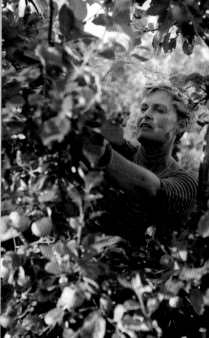

organic community orchard

'This was just a couple of overgrown plots at the very edge of the allotment site,' says Pauline Markovits, one of the original founders of the Horfield Organic Community Orchard, or HOCO, in Bristol in 1998. 'But there were a couple of big old apple trees on it, bullaces (*P. domestica insititia*) and plums, and some old blackberries.'

Though it is possible that these were planted by a former allotment holder, Pauline has a theory that they may have been remnants from the farmland that covered the area until the 1920s. Either way, a group approached the allotment association and was given permission to turn the plots into a community orchard. Now, the orchard contains over 100 different fruiting trees, bushes and vines, and has expanded to take in another plot that houses a polytunnel filled with apricots.

Co-ordinator Shannon Smith says: 'As a cook and food lover, having a stake in this place is a delight. We have 60 different apples to choose from, plus green and pink gooseberries, loganberries, apricots, grapes and more.' Members take home a share of the fruit harvest in return for a membership fee and a little work, but all go away with more than just the fruit. 'It's sociable and easy, and around the corner from my house,' says member Sally Barrow. 'And I end up with as much fruit fool and apple sauce as I can eat.'

growing notes

Members of the group meet up for fortnightly working meetings, at which all of the many chores of the orchard are shared out, along with the spoils. 'We make the working meetings educational, too,' says Shannon, 'so we'll put someone more experienced to work with a newcomer, to teach them how to prune the trees in winter or thin out the fruits in midsummer.'

The apples have been chosen to provide a harvest throughout the year – from early apples that ripen in late July to late-harvesting keepers that see the growers through the winter – but the original trees have never been identified. 'The tree by the bench is one of the originals. We thought it might be "Bell" but we're not sure, so

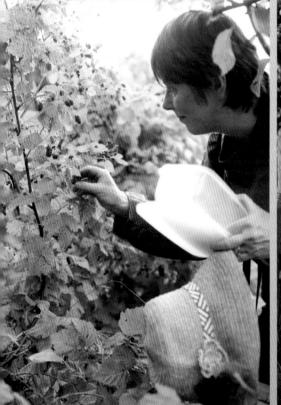

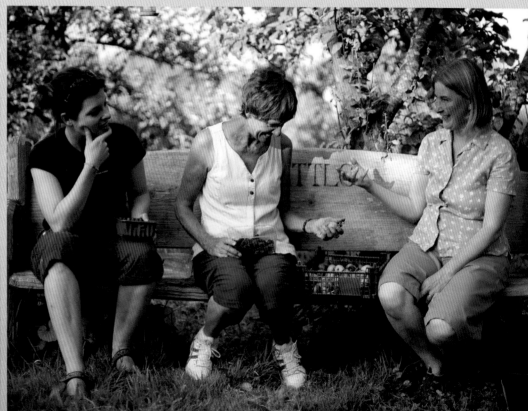

it just gets called "the Jim Little tree".' Jim Little left a legacy of £100 for a beautiful bench for the orchard, so it seems only fitting that his generosity should get him his own tree, too.

Come October, the whole community is invited into the orchard for a day of juicing apples, eating apple cake and identifying varieties of apple that they bring along, then in January, back they come again for the traditional wassail – singing and drinking (usually hot mulled cider) to the health of the tree. Member Angie Bambury says: 'I bring my daughter here often, and she thinks wassailing and apple day are just like Christmas and Easter. She thinks it's just what everyone does, and I love that. This is our little piece of countryside in the city.'

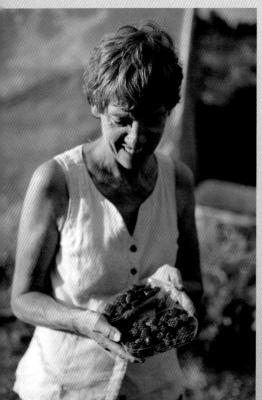

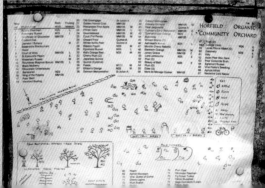

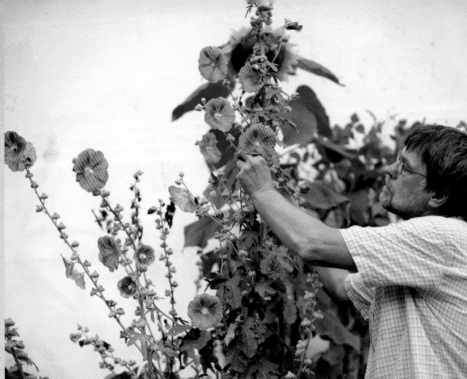

edible bus stop

Keith Heasman was walking along Landor Road in Stockwell, south London, one winter's day, when he spotted a cabbage growing across the road. He crossed over to have a closer look. 'There I found some herbs and kale, and the remains of some tomato plants. It was obvious that something was going on.' He went home and googled 'something like "garden, Landor Road, Edithna Street" and found The Edible Bus Stop, a then-fledgling group of local residents who had taken on the management of some near-abandoned council flowerbeds surrounding the Lambeth Hospital bus stop. He was hooked and has been involved ever since, earning himself the unofficial title of 'head gardener'. 'It seems the beds had always been vaguely "guerrilla gardened",' says Keith, 'but the real impetus came about when the site was earmarked for development, with two new houses planned.' Locals started a petition and sought permission from Lambeth Council to develop the garden. The council soon agreed.

Since then, the garden has been filled with edible and ornamental plants, all cared for by the community gardening group. 'Locals love it and passers-by always stop to comment on what a difference we've made,' says Keith.

There are now plans to develop gardens at other bus stops along the number 332 bus route. 'Bus-stop gardens are the most visible community gardens possible. They're not tucked away. It's the best possible way to get the community involved in gardening.'

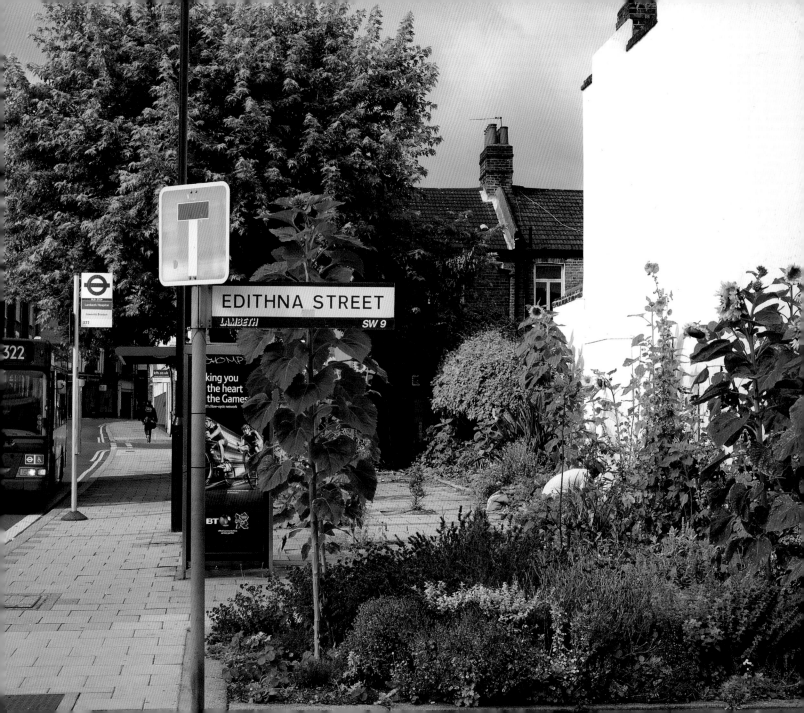

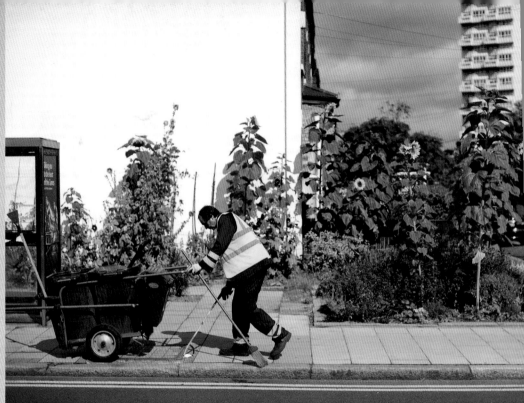

growing notes

The group meets twice a month for 'Dig Days', when members all work together, but they are encouraged to turn up and garden in between Dig Days, as Keith often does. They also have a number of guerrilla gardeners, who tinker with the garden without making any contact with the group.

'One man grows avocado and cherry seeds in pots in his back garden and plants them out here,' says Keith, 'and I've seen one lady push holes into the soil with her walking stick and sprinkle seeds in them.'

Wallflowers appeared unbidden this spring and there were a number of pumpkins that Keith doesn't recall planting. 'It's good that people feel some ownership, even if they're not officially involved.'

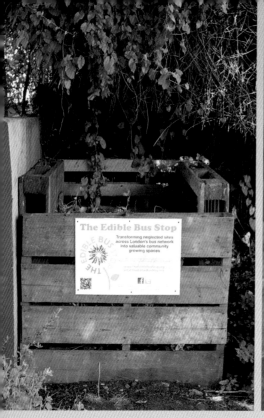

Such a public and open garden gets negative input, too. 'We've had some vandalism. People can't seem to resist having a go at the sunflowers. I guess it's when they're drunk and walking home from the local clubs.' In fact, since these pictures were taken, a car has crashed into the wall next to the bus stop, taking out the road sign and half the herb bed.

But Keith takes all this in his stride. 'This is never going to be a static garden. We'll just replant and keep on caring for it, and hope that more and more people feel moved to join in and care for it, too.'

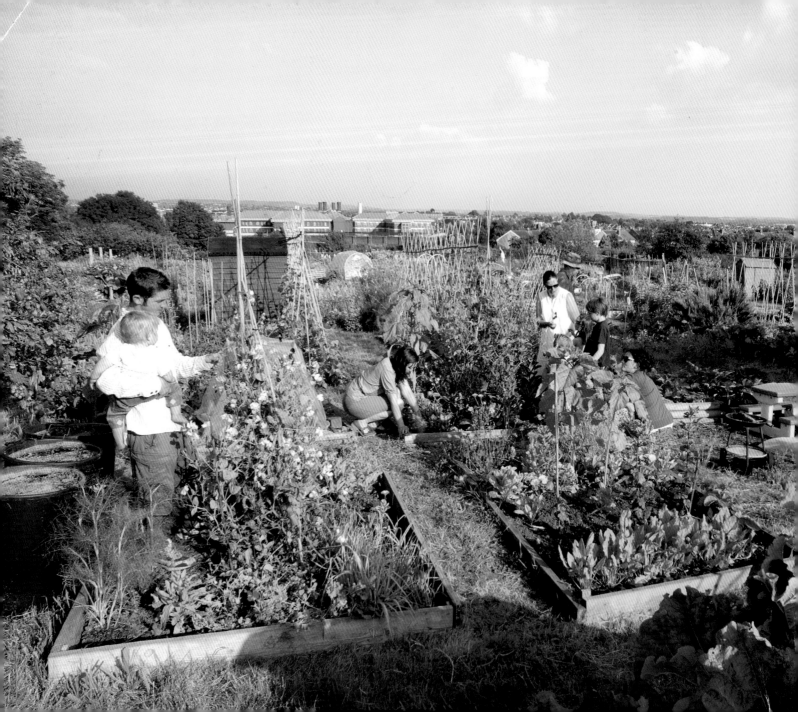

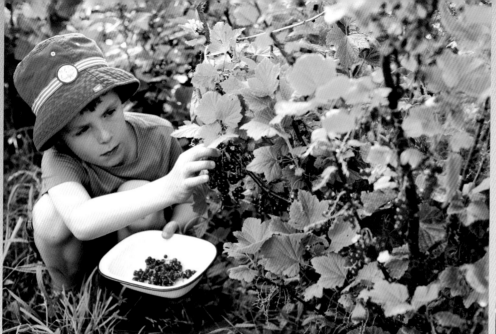

lia and friends

This is my own allotment, in north Bristol. My husband and I have had this plot for around eight years, but – mature fruit trees, view and all – we came close to giving it up three years ago, when he became ill. The allotment turned into just another drain on our already-stretched energies.

Instead, as an experiment, I approached a few friends whom I knew were either on allotment waiting lists or just keen on the idea of allotmenting. Everyone wanted to be involved, so now we all go up to the plot at the same time on Sunday mornings. The other families have kids the same age as ours, which makes for both fun and trouble. The children want to spend time with each other, but they make a hell of a racket when they do. The adults work while the kids climb the trees, make mud pies or hit things with sticks.

We all stop work for our mid-morning break and the ever-so-slightly competitive unveiling of freshly baked cakes. Every now and then we manage to have a meal up there, using the crops we have all grown together. As Jane says: 'It's important to me that the children see where their food comes from and that they have a place where they can experience the seasons changing. I love to see them climbing the trees and picking the fruit. They're city kids. These are things they wouldn't have without the allotment.'

growing notes

The challenge on a shared plot is dividing up the tasks and making sure everything gets done and everyone stays happy. As it happens, we all seem to have found our roles fairly naturally. Adam is a bit of a handyman, so he takes on the major DIY projects. Michael strims, weeds and builds, and Karen likes to clear new ground and has brought many a previously lost corner back into production. Jane has been instrumental in pushing us towards growing more flowers – we have roses, sweet peas, chrysanthemums – and we now aim to always take a bunch of flowers home each week. I've been left with the glamour jobs – sowing, planting and a little light supervising – and am very happy with that.

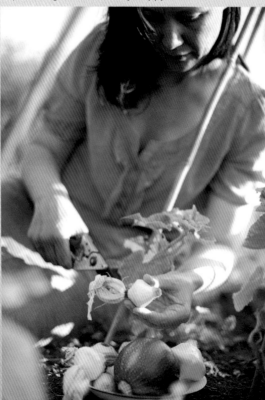

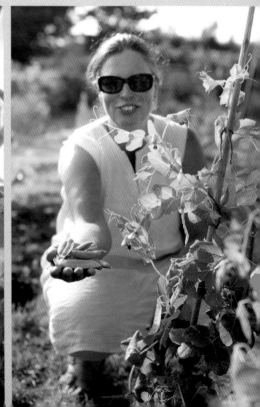

A second challenge is producing enough food for so many families. We still haven't cracked this one and often head home with two and a half carrots each at the end of a session. It means sowing entire packets, rather than just one row, and re-sowing weekly. High-turnover plants such as cut-and-come-again salad leaves and herbs suit us well – lettuce, sorrel, parsley, rainbow chard – plus those plants that produce such bumper crops that one family would quickly be sick of them – the fruit bushes and trees were made for us. This may not be the simplest way to run an allotment, but it has turned it from a worrying chore into a place of fun. We are still finding our way, but we are having special times together as we do.

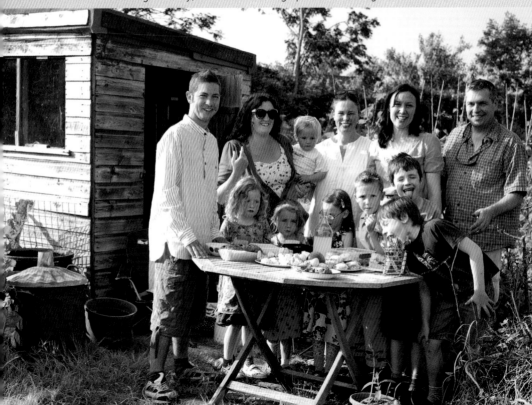

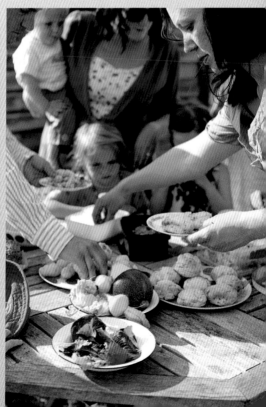

edible jungle

Traditional allotments are dug over every winter. Every spring, seeds are sown and planted out in neat rows. The rest of the year is spent keeping the soil around them clear of weeds, watering them and fending off the many things that try to attack them while they are in their vulnerable, young state. If you are lucky and put in the work, you get your rewards. No one ever said it was easy – and it isn't.

The gardeners in this chapter are all looking for alternatives to this high-input, high-risk way of gardening. Few of these plots would be approved of by traditional, old-school gardeners: to the untrained eye they are just messy. But there is a deeper logic at work here: these gardeners grow perennial edibles that leap into life each spring without the trouble of sowing seed. They leave the plants to seed themselves and grow wherever they do best. The result is a mixture of different plants, one of whose benefits is that they throw pests off the scent, so avoiding the need to spend an entire summer battling said pests. All of these plots walk hand in hand with nature in a way that the traditional allotment does not.

perennial crops for pioneers

If you wandered accidentally into Martin Crawford's forest garden, you would be unlikely to spot that you were in a food garden at all. It has the look and feel of the surrounding woodland: small paths lead among large trees, shrubbier trees grow below the canopy and everywhere there is dense ground cover. It does not look as if it has been 'designed', but it has.

'I worked in a market garden for a few years,' says Martin, 'and it slowly dawned on me that I was endlessly hoeing off weeds and battling against what nature wanted to do. It struck me that there must be a better way.'

He visited forest-gardening pioneer Robert Hart's garden at Wenlock Edge in Shropshire and was inspired by what he saw. Hart's basic idea was to plant edible and useful plants in such a way as to mimic the layers of trees in a woodland. 'Woodland planting is the system most suited to the UK. It is our natural vegetation, so I'm not constantly fighting the plants' natural inclinations. They grow as suits them,' he says. He has no need to cultivate the soil and a beautiful soil structure is slowly built up, which can hold water and nutrients, yet drains well.

All of this makes Martin's chosen crops less susceptible to the vagaries of our changing climate: 'Perennial food plants like these have deep roots and there's less risk of them getting wiped out by a drought or flood than there is with annual crops.' This may well be a type of edible garden that we see much more of in the future.

growing notes

'A forest garden has a much wilder feel than most types of garden,' says Martin. 'That's part of its appeal.' Despite this, he has found that he can grow equivalents to most of our annual crops here. 'There are great perennial alternatives to onions, such as Babington's leeks (*Allium ampeloprasum* var. *babingtonii*), and there are many fine salad leaves, like Good King Henry (*Chenopodium bonus-henricus*) that will grow in the undergrowth.' Martin loves cutting and eating his bamboo shoots in spring and is fond of other spring shoots such as Solomon's seal (*Polygonatum* x *hybridum* – boiled and eaten like asparagus) and the Ostrich fern (*Matteuccia struthiopteris*), whose young leaves can be sautéed in butter. Berries such as Nepalese raspberries (*Rubus nepalensis*) and wineberries (*Rubus phoenicolasius*) – eaten raw or cooked – are very happy in the shade of the fruit and nut trees that grow above.

The one food group that he can't grow easily, though, is carbohydrates: 'Being high-energy crops, they need lots of sun and they just don't get enough under a canopy.' So instead Martin concentrates his efforts on nuts – walnuts, hazelnuts and chestnuts – which grow happily here: 'We could all do with eating fewer carbohydrates anyway, and chestnuts have a very healthy balance of protein and carbohydrates. I dry and grind mine to make chestnut flour for breads and cakes.' The forest garden is now 15 years old and though such gardens are slow to establish, it takes very little maintenance and will be productive for a great many years, whatever the future may throw at it. 'Above all this garden has taught me the benefits of diversity.'

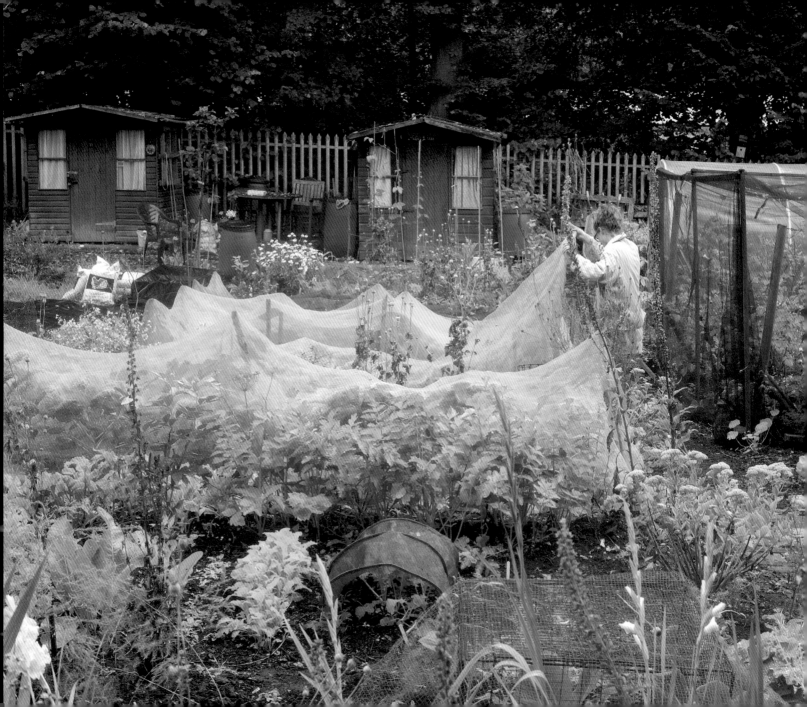

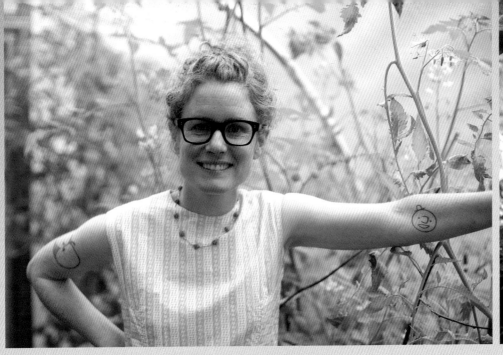

permaculture in action

As poster girl for sustainable gardening, garden writer and television presenter Alys Fowler has an allotment suitably packed with unusual crops and alternative experiments. It contains lasagna beds (a way of killing weeds and improving the soil without the need for digging), a hugelkultur bed (in which buried wood feeds and keeps the soil moist as it rots), a sunken bin (for storing apples, potatoes and root vegetables frost-free over winter) and many experiments in polyculture (growing mixed plants alongside each other as a way of improving their health).

This is also a place where Alys can indulge her cabbage fetish: 'I love fermenting crops as a way of preserving them through winter, and sauerkraut is one of my favourites, so I can't grow enough cabbages.'

She grows several unusual brassicas, too, including Portuguese cabbage (*Brassica oleracea* var. *costata*), a sort of perennial kale, and Asturian tree cabbage (*B.o.* var. *acephala*), a short-lived perennial that produces huge leaves from a central stalk.

Alys spends a chunk of every day at her allotment and it has now become an essential part of her work. 'I don't like to rush my time here. I come up for the whole afternoon, light a fire, make tea. It's my haven and my laboratory. My idea is to create a system here that other people can have a go at. I love being able to try out the things I want to write about.'

growing notes

'When I took the plot on three years ago, it was thickly covered in brambles, dock and grass,' says Alys. Rather than digging out all the weeds, Alys experimented with lasagna beds, with great success. First she covered the soil with a layer of thick cardboard, then added a layer of rough mulch, then a layer of shredded paper, then more cardboard, then a heavier mulch. She watered everything well, then left the whole for a season, by which time it had not only rotted down, but killed whatever weeds lay beneath. 'It cuts down on work, enriches the soil and leaves the existing soil structure intact. I've never had to dig this soil.'

Once the soil was clear, Alys created a series of long, thin beds with pathways in between. 'The beds are made to suit me, to the dimensions that I can work with easily.'

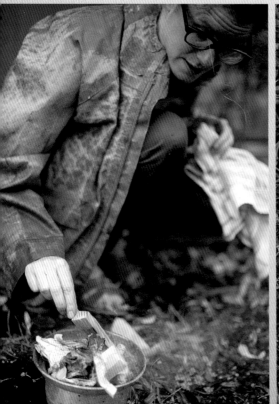

And this is where any attempt at straight lines of just one crop begins and ends. Within each bed, Alys sows a polyculture of mixed crops. One bed contains turnips, beetroot, celeriac, cabbages and a few carrots; another, fennel, beetroot, spring onions and buckthorn plantain (*Plantago lanceolata*). 'I see a real reduction in pests and diseases by growing crops this way. It confuses the pests. The larger, slower-growing plants such as fennel and brassicas create shelter for the quicker ones such as radishes, lettuces and carrots, and I've cropped the quicker-growing ones before the larger ones need the space.'

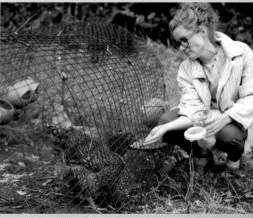

experiments in sustainability

Bristol permaculture guru Mike Feingold is getting excited about radishes. 'The seedlings mark out the rows for the slow-germinating parsnips and open up the soil for them. I can eat the root – or radish – later. I can also let the radishes flower and go to seed, then I can eat the seed pods in salads or I can sprout the seeds and eat them.' This is permaculture in action, says Mike. Minimum input, maximum output. Permaculture is an approach that is modelled on relationships found in nature. Its practitioners work with natural processes and systems in the most effort-efficient way or, put more simply, they grow food without trying too hard.

Mike points to digging as an example of the 'make-work' culture of traditional gardening. 'It's crazy. As soon as you've got bare soil, plants colonize it. It wants to be forest. And yet every year you put a huge amount of energy into making it bare again.' His four plots exist to demonstrate, trial and teach permaculture principles, and contain examples of polyculture and forest-garden planting. Mike took on the plots when the site was threatened with sale in the 1980s. The site was saved and two of the plots have been turned into a community plot that is shared by whomever wants to join in, while the other two are Mike's own personal playground.

But permaculture is not just about making gardening easier: the vision is far wider than that. 'Every time you bring in inputs – fertilizers, water – you're plundering them from somewhere else, another part of the world that likely needs them more. system of growing depends on this. We need to take responsibility for our actions.'

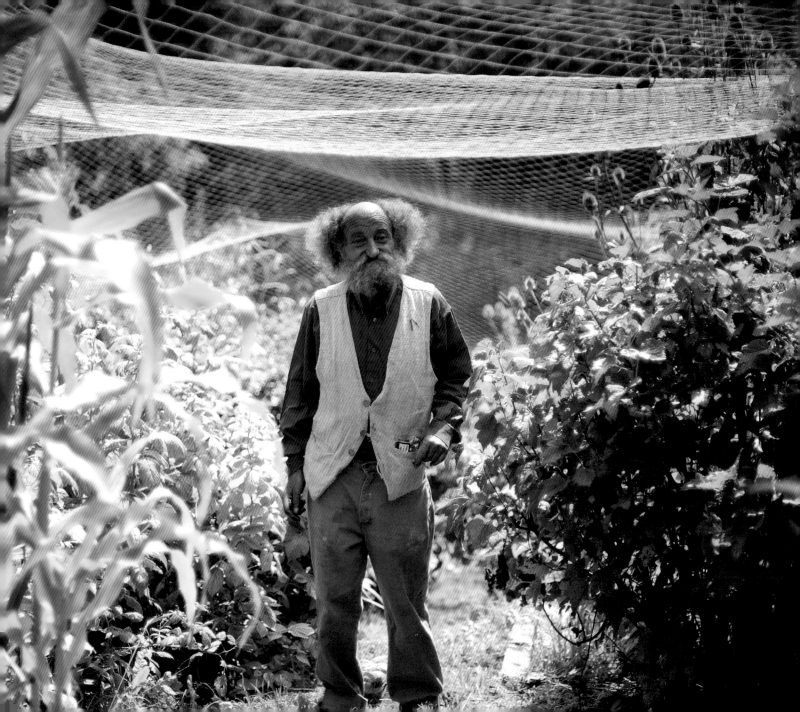

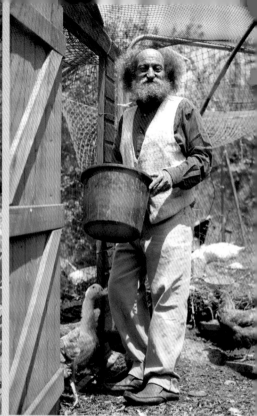

growing notes

Mike is keen to stress that the aim of the plots is not just to provide a series of techniques, but to foster an idea and a new way of looking at the world. The permaculture way of looking at the world is such that it facilitates the discovery of neat little solutions. One such is mound planting. Mike's site is on a south-facing slope and he has created a series of mounds that run horizontally across the slope. 'The soil on the front of the slope warms up first, so the crops there are earlier and grow faster,' he says. On one he has planted sweetcorn, on another, lettuces and on a third, carrots. The plants towards the back mature more slowly, it is true, but that helps to spread the harvest so that it arrives a little at a time.

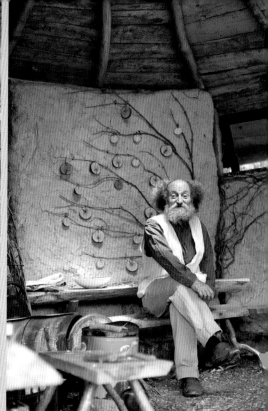

He has applied another clever solution in the vicinity of his hen and duck house, a crazed construction bodged together from abandoned building materials, but apparently entirely fox-proof. 'My rule for the chickens is that I won't buy them any food, so they are fed from vegetable scraps I collect from the plots and from local restaurants.'

Worrying that his chickens were not getting enough protein, Mike placed old planks and rounds of wood around the hen and duck house, directly onto the soil. 'Then each day I lift one piece of wood and brush whatever has crawled onto the bottom of it into a bucket for the chickens.' Not only does it provide protein for the chickens, but it is also a neat way of keeping down the slug population.

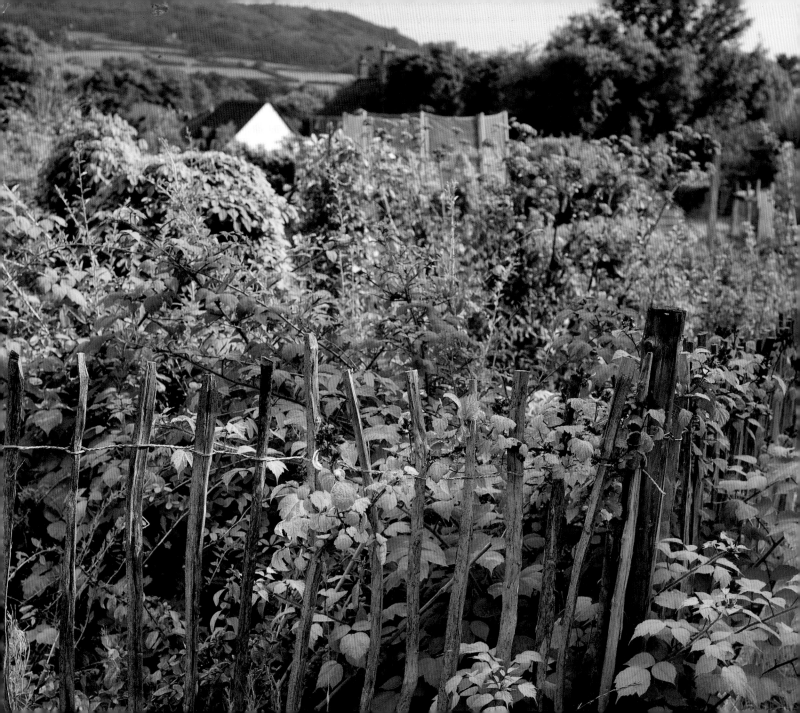

practically perennial

Mark Diacono – the photographer for this book – has his own unusual take on an allotment. It isn't strictly an allotment since it is sited on his seven-hectare (17-acre) smallholding, but it is very deliberately allotment-sized. 'I think the concept behind forest gardens is wonderful, but most are planted on a large scale, ¾ of a hectare (2 acres) minimum, and people can't relate to that.' He wanted to prove that the forest-garden concept (see p.92) would work on an allotment-sized plot.

'Perennial plants are more resilient to change and adversity but they also produce really interesting crops – many very early in the year,' says Mark. His garden includes some of the best plants to fill the 'hungry gap' that allotmenters suffer between finishing off their stored winter crops and the start of their spring and early-summer crops. 'Annual crops are trying to throw down a root system in adverse conditions at the beginning of the year but perennials already have one established, so they just grow.' His Himalayan rhubarb (*Rheum australe* – a bigger, more ornamental edible rhubarb), blue honeysuckle (*Lonicera caerulea* – with sweet blue berries) and Solomon's seal (*Polygonatum* x *hybridum* – with its tender, asparagus-like shoots) are all productive at this time.

Being more garden-like than the average edible garden, Mark's plot has become a favourite spot with his young daughter, who plays here but also enjoys harvesting and tasting. 'She's very inquisitive and by making an edible garden, we've created a place where nothing is off limits, everything can be tasted and sniffed. This is her playground.'

growing notes

Forest-garden plants are used to create a series of tiers of planting, with canopy, shrub layer and undergrowth being the principal ones. In this smaller-scale forest garden, Mark is still able to replicate each of these tiers but has needed to be careful in his choice of trees. 'I couldn't use any big canopy trees, as they would have cast too much shade, so I've only planted trees that have smaller canopies or those on dwarfing rootstocks.' These include damsons, plums, mulberries, peaches and a dwarf quince, all planted around the edges of the plot in order to cast as little shade as possible.

Beneath these are shrubby plants and climbers such as Szechuan peppers (*Zanthoxylum schinifolium* or *Z. simulans*), Japanese peppers (*Z. piperatum*), wineberries (*Rubus phoenicolasius*) and salmon berries (*R. spectabilis*), all of

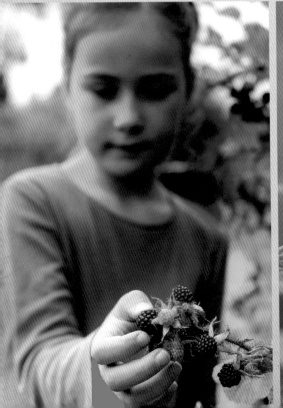

which thrive in light shade. A thick ground cover of Moroccan mint (*Mentha spicata* var. *crispa* 'Moroccan') and alpine strawberries (*Fragaria vesca*) keeps the weeds down and is punctuated by low-growing plants such as day lilies (*Hemerocallis*) with their edible flowers and the perennial substitute for leeks – Babington's leeks (*Allium ampeloprasum* var. *babingtonii*).

'It isn't the same deal as with a traditional allotment. An allotment is high-input in spring and high-output later that same year.' Now that it is planted, Mark's garden requires extremely low-input – Mark estimates he spends around two days a year weeding – but produces a trickle of delicious things. 'There will never be the equivalent of the huge abundances of courgettes and potatoes you get on a normal allotment. This garden will never produce bulk, but it does produce flavour'.

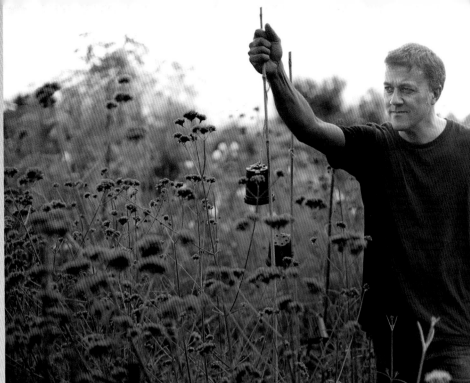

garden designer's artful plot

Garden designer Cleve West and his partner Christine Eatwell's plot is an artful tangle of flowers, fruit and vegetables, plus the occasional weed. 'Being neat and tidy just isn't in our natures,' he says. He recently visited Strilli Oppenheimer's Waltham Place in Berkshire, where, influenced by late garden designer Henk Gerritsen, weeds are embraced and celebrated for their natural beauty. 'It was quite magical and it's helping me to be philosophical about my allotment.'

A plot – or, more accurately, four plots joined together – with such strong, handsome lines can carry it all off. There is an easy style about the place. The lightly chaotic whole is pulled together with the unusual use of black paint on all the wooden structures ('I love the way black shows up plants,' says Cleve) and there are wide paths, many trained fruit trees and several wonderfully eccentric sheds, which all combine to give the plot its strong architecture.

Work here is shared between Cleve and Christine equally, but Christine is particularly good at 'the lifestyle stuff. She'll lay the table and pick a vase of flowers to make it all look beautiful.' Meals at the plot are important for them and they recently built a wood-fired oven to make pizzas using the tomatoes, peppers and rocket leaves they have grown. 'We always spend the day up here and slowly started inviting people to join us for lunch. It makes it more fun.' They have made a great many friends on the site. 'Here no one gives a damn if you've just won a gold medal at Chelsea, and that's quite a relief.'

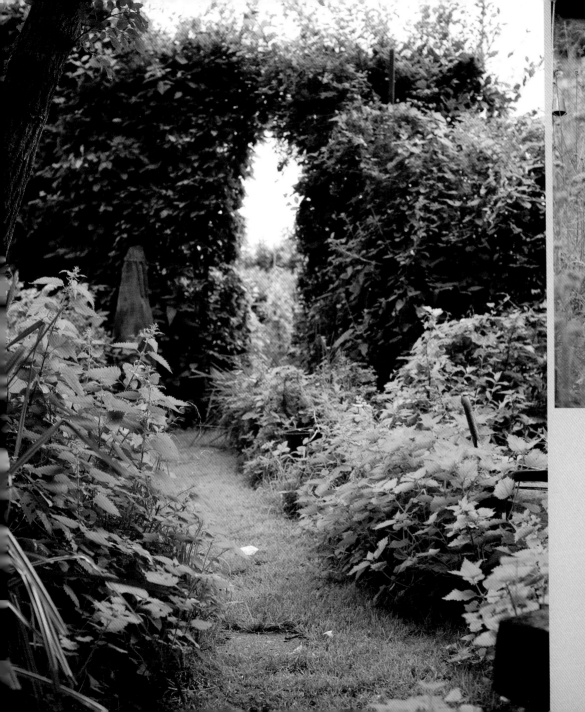

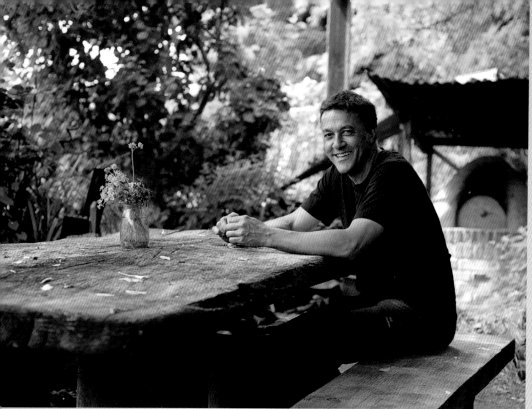

growing notes

One of the unusual decisions Cleve and Christine have taken is to avoid deliberately killing pests. 'It's a bit of a stupid way to garden, to be honest, but neither of us can face killing them,' he says. Slugs are collected up and deposited across the stream that runs along the bottom of the plot. 'It limits what we can grow. I'd love to grow dahlias and cleomes and other tender annuals, but there's no point.'

Instead, the colour in the plot comes from self-seeding flowers – verbenas, nasturtiums, pot marigolds (*Calendula officinalis*), nigella and borage (*Borago officinalis*), which appear in such numbers that something always survives the slugs. Christine loves the big, colourful flowers and wispy foliage of cosmos, so that is the only flower seed they sow and then protect jealously from slugs while the seedlings are young.

Getting their seed sown proved rather tricky during the many years when Cleve was designing gardens for the Chelsea Flower Show. 'I'm away building the Chelsea garden from April to June, which is prime time for the allotment. It's a bit hopeless in those years.' Because of this they take the self-seeding approach with some of their vegetables. It works particularly well with herbs, lettuces and parsnips. 'I like the big, yellow umbels of parsnip flowers, so we let them flower and set seed. They look beautiful and then sow themselves all around for the following year.'

roof garden with a global message

'The whole of the school curriculum can be taught through a garden,' says Dave Richards. He is talking of the rooftop garden that bursts from atop the offices of RISC, the Reading International Solidarity Centre, used for teacher training. 'Our mission is to raise awareness among teachers about global issues. A garden is a particularly useful tool for teaching global citizenship. In a garden, students can learn about food security and water shortages, but in a very positive way. We're talking about the threats but we're also showing how to solve the problems in reality.'

The organization always wanted a permaculture garden (see p.97), so ten years ago they brought in local permaculture designer Paul Barney, who suggested a mixed planting along forest-garden lines (see p.92). So the rooftop garden – though the soil is only 30cm (12in) deep – was planted with permanent perennials and forest-garden plants, with some of the trees now reaching 4m (13ft) in height ('a testament to organic horseshit,' says Dave).

Plants thrive in the shelter afforded by the buildings on each side. Oca (*Oxalis tuberosa*, a South American crop, similar to new potatoes), crab apples, kiwis, cherries, snow pears (*Pyrus nivalis*), blue beans (*Decaisnea fargesii*), treacle berries (*Maianthemum racemosum*), medlars (*Mespilus germanica*) and figs have all proved bounteous and fruitful.

'Sustainability, access to land and resources – these are the big challenges that face humanity and that these children will grow up to wrestle with. But this garden is a living book, and one we are using to teach the teachers.'

growing notes

'This rooftop garden is essentially a huge hanging basket,' says Dave, and the problem of how to keep it watered exercises him. 'These last few wet summers have suited it well and we've also installed large tanks to collect water from this and surrounding roofs via a series of gutters and pipes.'

But he is aware that a prolonged drought could finish this garden. 'We're in the process of building much bigger tanks. We have to plan for climate change, so we aspire to be independent of mains water.' Always wanting to pass on the lessons, Dave has installed an achievable gravity-fed irrigation system at one end of the roof garden. 'It's essentially a bucket on a rock attached to a drip hose,' he says.

One of the principal benefits of gardening here is the lack of perennial weeds. 'We don't do battle with bindweed or couch grass,' says Mary Tindall, who looks after the garden. In fact it is all very low-maintenance. 'There's a little weeding early in the year, but after that I just clear the paths and pick the produce. I like the garden to be just the right side of wild,' she says, sidestepping a mushroom that has sprouted at the base of one of the trees.

Mary is delighted by the state of the soil. 'It all came from potato washings. It was entirely sterile. There was no life in it at all when we started. But we add horse manure and we don't dig. Now it's full of worms and other organisms.'

High on its rooftop, the RISC has taken a barren, vacant city-centre space and turned it into a productive and instructive oasis.

food from home

When you are far from home and everything seems alien, growing a familiar crop can be a touchstone, a link to the past and a very straightforward way of engaging with a new land. It is often the lot of the immigrant to land somewhere urban: the inner city is where cheap housing and jobs lie, and these are often the primary needs of the newly arrived. But it is also an entirely built environment, cut off from land – unless you take on an allotment.

It is perhaps for this reason that some allotments are filled with crops from around the world: callaloo (*Amaranthus viridis*) from Jamaica, yams from Africa (*Diascorea*), lemon grass (*Cymbopogon*) from Thailand, tinda squash (*Citrullus fistulosus*) from Pakistan, Chinese shark fin melon (*Cucurbita ficifolia*) and Japanese aubergines (*Solanum melongena*). The ingenious gardeners on these allotments have tracked down seeds from home or via enterprising seed companies, or have nursed into life scraps of roots or leaves bought from food shops. They have managed to find the best ways to grow their crops in an uncertain climate while enriching their new horticultural environment at the same time.

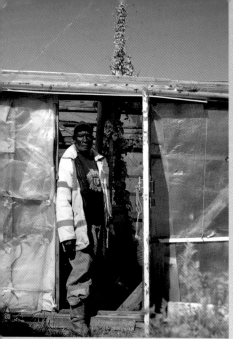

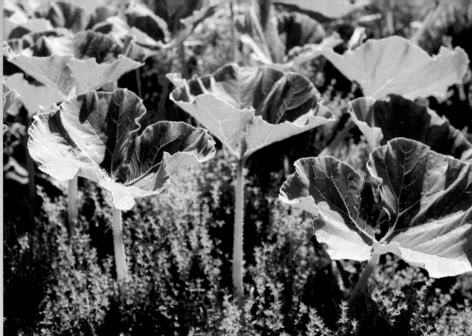

moonstruck jamaican

Glandel Archer, mysteriously known everywhere on his allotment site as Lee, is a man of the world. Lee has worked as a farm hand in Canada, Australia and Florida, not to mention in his home country of Jamaica. 'Me know all about the world and me know how things grow,' he says with the utter confidence of a man who has seen it all.

Lee leans a little to the mystical in his gardening style – 'Me study the moon and plant the seed by that. Plant the pumpkins three days before the full moon: all set' – and you can't argue with his pumpkin patch, which romps abundantly across half of one of his three plots. Pumpkins are one of the most easily recognised of Lee's crops. His other main crop is callaloo (*Amaranthus viridis*), a leaf vegetable eaten much like spinach and popular in Jamaica and India. Swathes of it take up a large proportion of many a plot on this Birmingham site.

Asked why he chose Birmingham to settle in when he had the whole world at his disposal, Lee looks surprised. He may be nearing 70 but his wanderlust is obviously far from over. He has always wanted to visit China, he says, and has never been to Africa. 'Who knows what tomorrow bring? Me can't say me settle yet.'

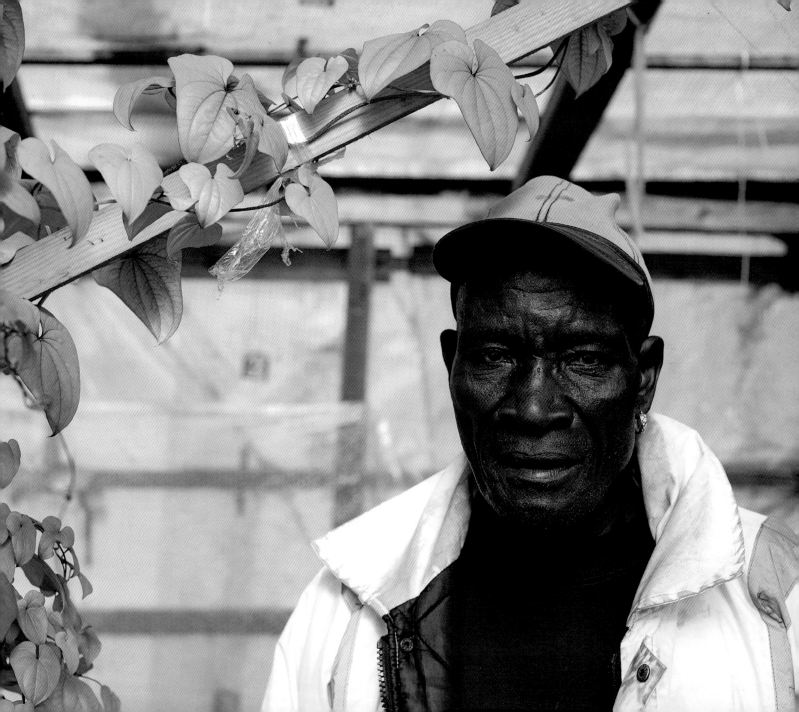

growing notes

'There is nothing you can't grow here,' he says, 'you just give a little more light, a little heat. You need to become a scientist.' Lee proves this by growing crops such as okra (*Abelmoschus esculentus*), tamarind (*Tamarindus indica*) and yam (*Diascorea*), in the large and spectacular greenhouse he has built himself. All need warmth through winter and cannot take a frost, so he heats the greenhouse when it turns cold, and even, on particularly chilly days, lights a little fire in it.

He does this occasionally in summer, too, to help protect his cucumbers, tomatoes and chilli peppers from pests. 'The smoke keep away the flies,' he says when I ask him about a small patch of ash and blackened wood situated perilously close to one of the greenhouse's wooden supports.

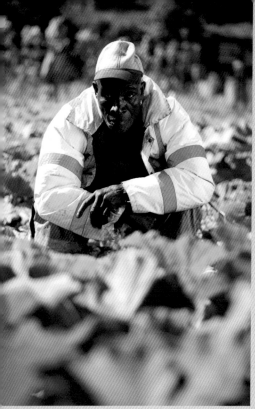 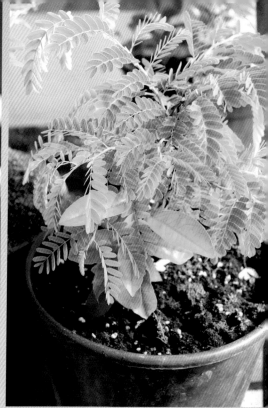

He is particularly fond of the yam, which he has now kept going for 15 years. Each spring he places a plastic bin with its bottom sliced off onto the bare earth in the greenhouse, packs it with mulch and compost, and plants one tuber into it. Though it needs heat at the start of the year, it also needs to stretch out later on, so Lee has made a hole in the roof through which emerges a pole for the yam to run up and bask in the sunshine. It will convert all that energy into making big, fat yams.

Yams are a crop Lee loves to share, dividing offshoots to grow on and tubers to eat among his fellow-Jamaicans. They are a piece of home that Lee has brought alive through ingenuity and gardening know-how. 'Each year me reap maybe 15 yam. Some for eating, some for next year, true. Most are for friends.'

thai treasures

Pheeraya Hill, known as Nid to her friends and family, grew up cooking and gardening. 'Everyone in Thailand has a garden and everyone grows food. We harvest and cook fresh food every day. As a child you pound the curry paste, so the knowledge is in you. It was just a part of growing up.'

Nid moved from her home near Chiang Mai in the north of Thailand when she met her British husband, Jeremy, 20 years ago. 'I thought I'd never grow anything again!' she says. 'It seemed so cold in England.'

But her natural curiosity and love of cooking set her on a relentless search for familiar crops that she could grow in the UK and for substitutions for those she couldn't. 'When cooked, oregano has the same taste as one of our most commonly used Thai herbs,' she says, 'so I use it all the time. Chervil, dill and mint can also be used; all are similar to some Thai herbs. It frustrates me to visit a Thai restaurant where they haven't used these because they're not the real thing. They're so similar and they're all around you.'

But her real love is for the exotic and her greenhouses are packed with plants that she is trialling. She visits Thailand once a year and goes on a hunt for unusual vegetables that she can bring back to England. 'Next time, I'm determined to bring back a tiny loofah. We use them for curries and stir-fries. I think they'll grow well in my greenhouse.'

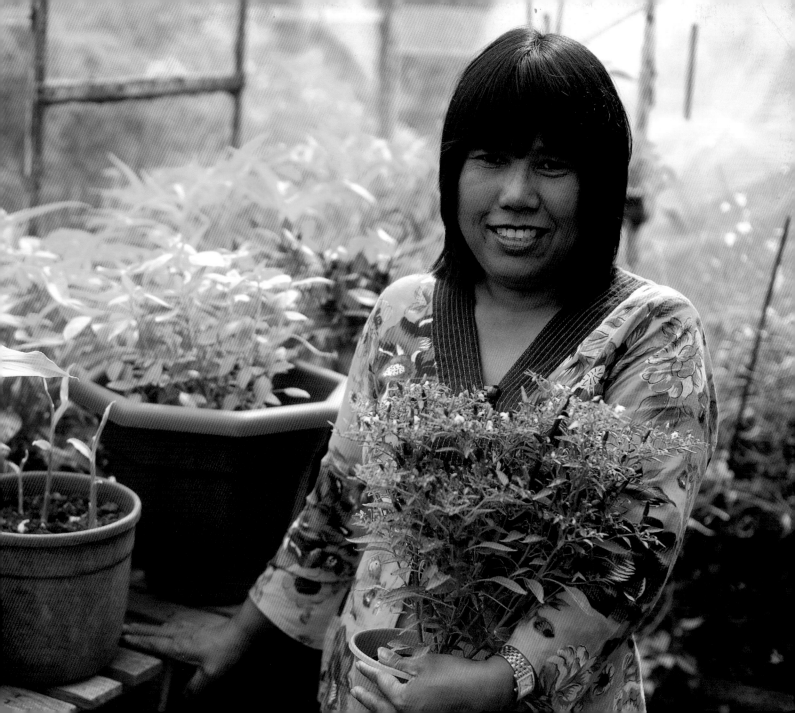

growing notes

'I quickly learned why people have greenhouses here,' says Nid. 'I can grow almost everything I want with my greenhouse.' She now has two, plus a polytunnel, each of them packed full of lemon grass (*Cymbopogon*), Thai bitter gourds (*Momordica charantia*), Ceylon spinach (*Basella alba*), Thai basil (*Ocimum basilicum* 'Siam Queen'), rats-tail radishes (*Raphanus sativus* var. *caudatus*) and chillies.

Rather than getting frustrated at her crops' inability to mature fully in the UK, Nid often makes use of the parts that will grow: the leaves. 'Ginger will never make enough of a root here – there's not enough warmth – but I chop the leaves into stir-fries, as they have the same taste. Kaffir lime (*Citrus hystrix*) leaves have the same flavour as the zest of its lime that we use in Thailand and I use turmeric (*Curcuma longa*) leaves and sweet potato (*Ipomoea batatas*) leaves in curries.'

Nid has also found that some of her favourite ingredients, such as bamboo shoots, will grow quite happily here: 'I cut them when they are around 20cm (8in) long and strip out the middles to make a lovely bamboo-shoot curry.' She grows huge amounts of coriander outside but doesn't understand why people get upset when their coriander runs to flower and seed. 'Use the seed! It has a wonderful flavour, especially when fresh.'

Nid runs popular Thai cookery lessons, so it is important to her that she can find the right ingredients, 'but I always prefer to use something that I can grow here.' Her natural resourcefulness means she never runs short.

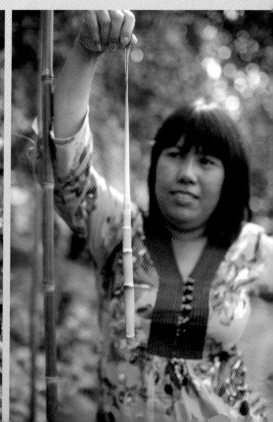

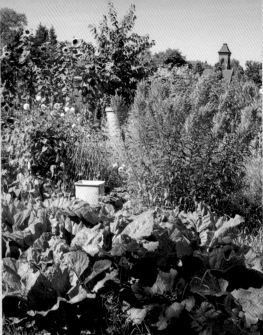

cyprus transplanted

Edible and ornamental plants were rarely grown together in the garden of Beyda Mehmet's Cypriot childhood home. 'We had a beautiful garden of lemon trees, walnuts, figs, vines and vegetables, but they were kept separate from the flowers. The flowers were grown by the house, the vegetables in the rest of the garden.' She often gardened as a child and took marrow flowers and artichokes to the market with her parents.

On arriving in the UK, Beyda and her husband ran a fish and chip shop. 'It had a tiny yard out the back and I was desperate for a garden,' she says. So she took on an allotment.

Now Beyda has two: one for vegetables and one for flowers. Both stray a little from their original plan, with huge sunflowers popping up near the pumpkins, kale and chard of the vegetable garden, and figs and lettuces creeping in among the cosmos, dahlias and zinnias of the flower garden. 'Whatever flowers I have in my garden at home, I bring some of them here to the flower garden and plant them out, but I don't mind seeing a few vegetables in with the flowers, too. I like the look of them.' The flowery plot was deemed ornamental enough to have recently won joint first prize in her allotment society's 'Flower Garden' competition. 'Last year I won first prize,' notes Beyda.

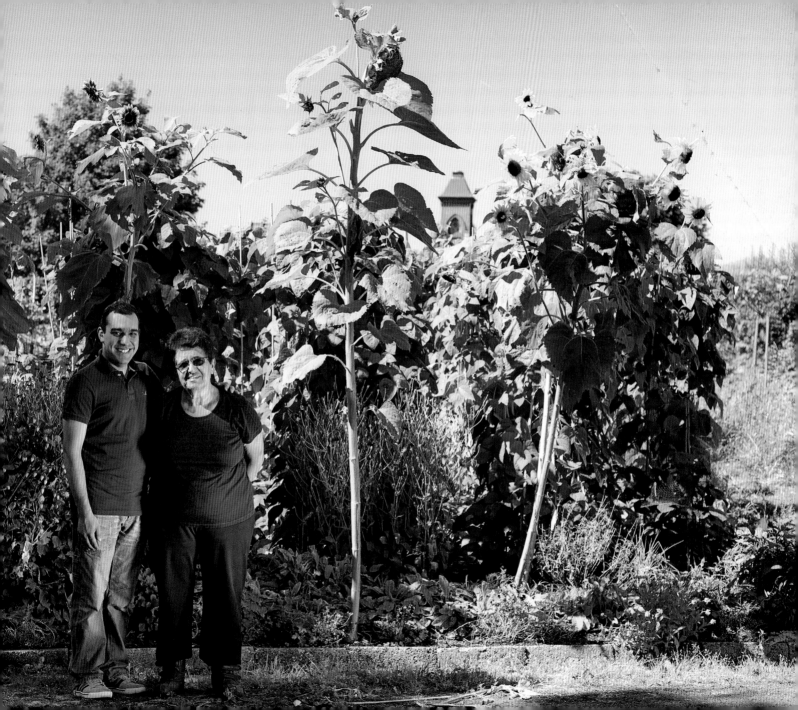

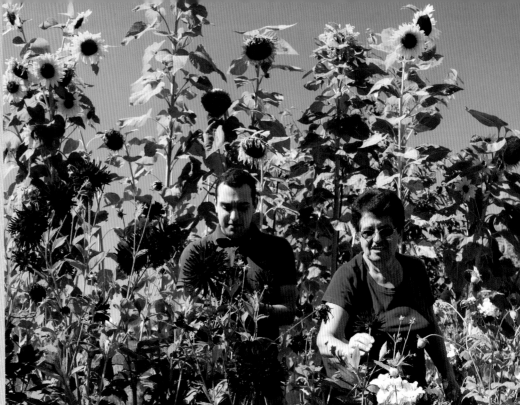

growing notes

Beyda has passed her love of gardening on to her grandson Arif, and though Beyda is clearly in charge, this plot has become a joint project, with Arif joining in whenever he is home from university. 'I looked after him a lot as a baby. He always gardened, from a child, just like me,' says Beyda proudly, while Arif says, touchingly: 'In summer Nan's never at home. I realised that if I wanted to see her, I had to come to the allotment.'

They clearly enjoy their time together and have created a beautiful area under a huge vine on the flowery plot, where they can sit and plan their gardening. 'I'm always here when the weather's right,' says Beyda, 'and I like people to drop in and talk.'

The vine occasionally produces fruit, but Beyda puts it to another use. 'When the leaves are soft and young, I pick them and use them to make *dolma*.' Mince, herbs, rice and onions are wrapped up in the young leaves and then simmered gently in a little water for 20 minutes. 'I can buy the pickled leaves in the shops, but I like to use these fresh ones, then it's just like at home.'

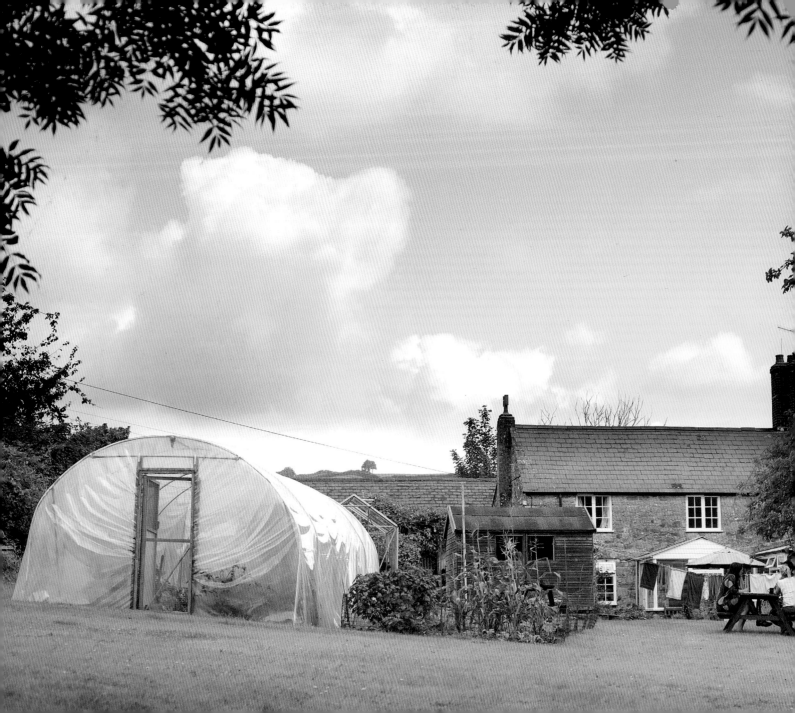

tempura and teppanyaki

Shige Takezoe wasn't much of a gardener in his home town of Tokyo. 'There isn't much space there. There's no opportunity. Tokyo is built up. Concrete. You never see sheep.'

Though he always loved eating out, he wasn't much of a cook either. But all this changed when he met his English wife Diana 22 years ago, and together they moved to England and into their Dorset smallholding.

Here Shige suddenly had space and found he yearned for the food he was used to eating in Japan. He started growing the Japanese vegetables that he had no hope of tracking down in rural Dorset, and teaching himself what to do with them. 'I knew how the food was meant to taste; I just had to work out how to cook it.'

And cooking it is what he now does extremely successfully. These days he regularly cooks Japanese meals for guests who stay at his and Diana's rental cottages, as well as for an occasional pop-up restaurant that they run from their sitting room whenever there is the demand, usually around once a week.

He raids his garden and polytunnels for a tempura starter, dipping the raw vegetables into a thin batter and deep-frying at a high heat, and for a teppanyaki main, a long, slow meal that involves cooking 13 rounds of different ingredients in front of his salivating guests on a special iron grill.

growing notes

'I love the texture of Japanese cucumbers,' says Shige. 'They're particularly crisp and I slice them and dip them into a sweet miso. And I like the tiny Japanese aubergines (*Solanum melongena*) that I've found grow well here. They're much sweeter than the aubergines we can buy and they're easier to grow because the fruits are smaller. I score the outside and grill them until they're collapsed and gooey, then I put soy sauce on them and eat them.'

When friends visit from Japan, Shige asks them to bring seeds. He has slowly worked out what grows well and has built up a collection of familiar varieties.

Most of Shige's growing is carried out under the cover of a large polytunnel and two greenhouses. Some of the plants, such as his shishito peppers (*Capsicum annuum* 'Shishito' – mild, sweet peppers that are delicious served whole as tempura) need that extra heat. His pak choi (*Brassica rapa chinensis*) and Chinese cabbage (*B.r. pekinensis*) – whose main growing season is autumn and winter – produce nicer, more succulent leaves under cover. Other crops, such as mooli radish (*Raphanus sativus* var. *longipinnatus*), a large, hot, spicy radish that Shige grates and mixes with soy sauce as a dressing for steak, can be grown outdoors or in.

The people of Dorset certainly seem to appreciate Shige's efforts. 'People are falling over themselves to come and eat here,' he says, a little baffled but delighted to be sharing his new skills – and his vegetables.

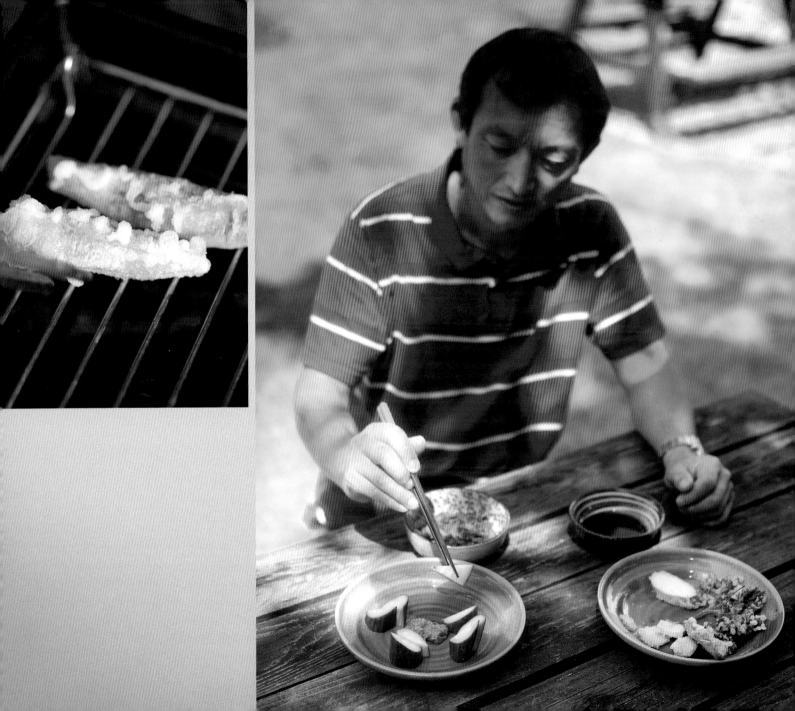

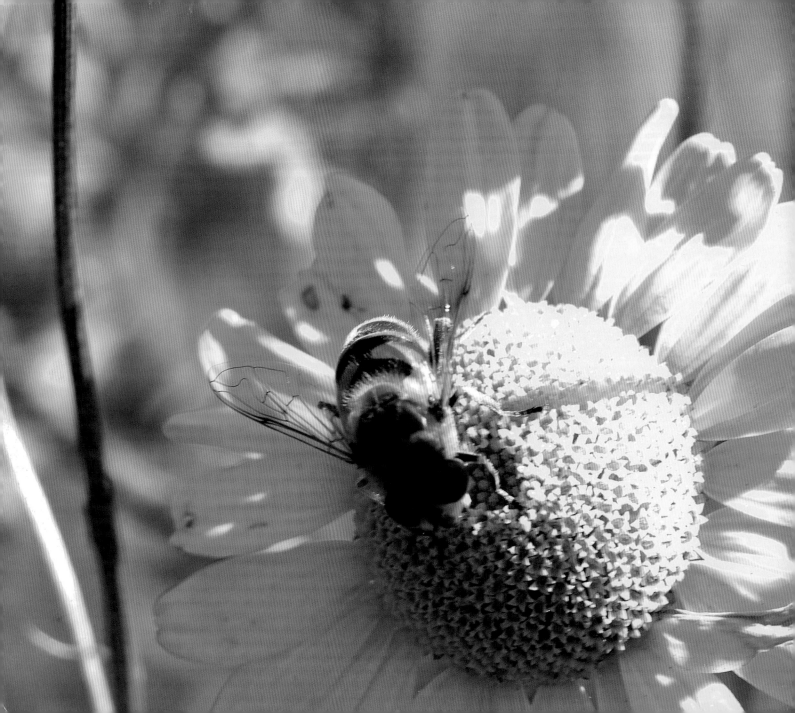

the creative process

For most of us, processing our allotment produce is something we do to cope with an influx: I suddenly have all of these potatoes, I must deal with them. We scout around for recipes and eat what we can, by which time a good chunk of what we have grown is past its best and ends up on the compost heap.

The growers in this chapter approach their plots in an entirely different way. They have realised that processing is the key to turning home-grown produce into gold. It is this final burst of energy that makes it all worthwhile and that separates the spud from the fondant potato.

These growers are single-minded, even verging on the slightly obsessive, about their particular product. For them, this is what is important: the growing is simply the means to the end.

It is a good lesson. By starting with the end product and working backwards, we could all keep more of our hard-grown veg from being wasted at the final hurdle. So before I plant these leek seeds, I may just look out the recipe for leek and potato pie.

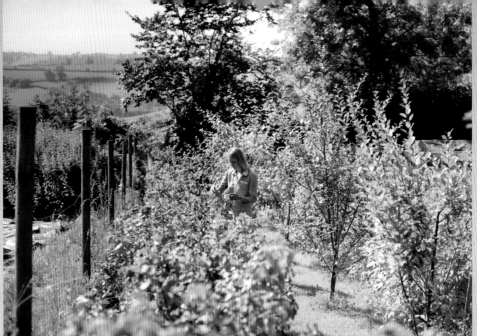

from orchard to table

There is no such thing as a fruit glut for Rachel Baker, no agonising over how to use up or preserve these apples or those pears. Rachel knows exactly what she is doing with each of her crops: everything is what she expected and is what she wants because everything was planted for a reason. Rachel is unusual among allotmenters in that she had her end product in mind before she started growing. 'I always wanted to make beautiful and unusual jams, curds and fruit vinegars from fruit that I'd grown myself,' she says, 'so I look forward to processing every harvest.'

Her first step in planting up her allotment was to think about the flavours she wanted to have at her disposal. 'I thought there was little point planting fruit that I could find in the shops, so I looked for more unusual things. Yellow raspberries (*Rubus idaeus* 'Allgold') have become a great favourite of mine: they have a delicate, slightly citrusy taste and they make fabulous jam.'

Rachel turns tiny alpine strawberries (*Fragaria vesca*) into little pots of intensely flavoured jam. Figs become fig cheese, blackberries are turned into blackberry curd, and pears are magicked into spiced pear caramel. Occasionally she has to source fruit from a local supplier or go foraging nearby for wild damsons and bullaces (*P. domestica insititia*), but to ensure she produces as much as possible with her own hands, she also has a small flock of chickens, which supply the eggs for her curds.

To complete the circle, Rachel now sells the preserves in farmers' markets and via the internet, under the name 'With Her Hands'. 'I love having taken control of the whole process. I've chosen, grown, harvested and preserved this fruit.'

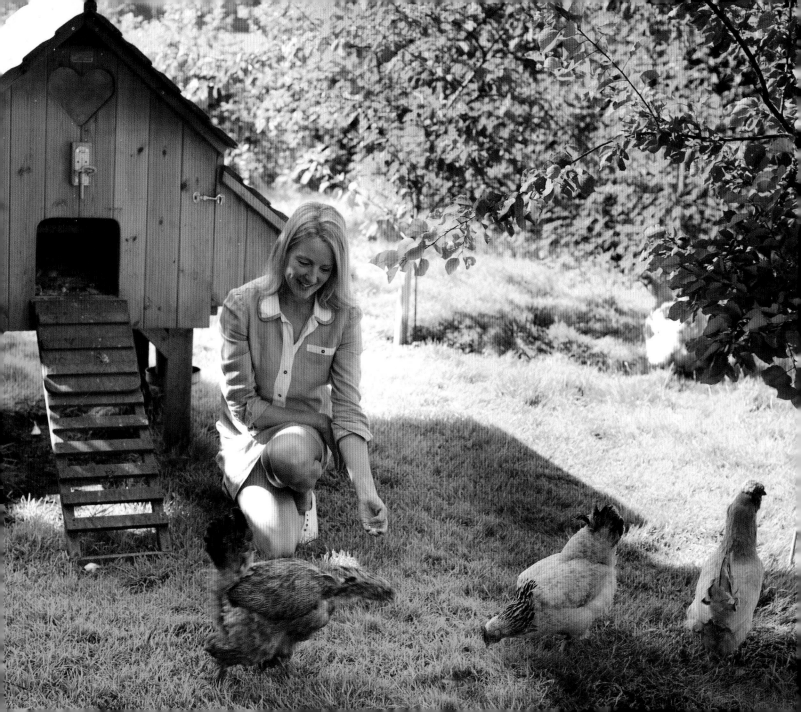

growing notes

Rachel's plot is on a south-facing slope in a small village near Bath, protected by a belt of trees on two sides. It is the perfect fruit-growing spot, sheltered and sunny.

'The only problem here is the deer,' she says, 'which would strip all the plants, given a chance.' Her most precious crops are now barricaded inside a large enclosure built by her husband.

Great growing conditions are all very well, but Rachel knows that without good pollination there would be no fruit. She has recently started keeping bees, partly so that she can eventually add her own honey to her range, but also for their pollination services. 'The other plot-holders are grateful, too,' she says.

Rachel has developed her own technique to ensure that she gets the most out of her fruit. 'I macerate the fruit first, leaving it in a little sugar and lemon juice

overnight to draw out the juices.' She then drains off the juices and makes the jam from these, adding the fruit for only the final ten minutes of boiling, thus stopping it from disintegrating. 'So if I combine loganberries and apricots, you'll still see each fruit in the jar.'

She does combine these two and has a particular knack for other unusual combinations – gooseberry and angelica jam, blackcurrant and amaretto jelly, blackberry and chilli syrup. The lucky customers at the farmers' markets are starting to get a taste for Rachel's delicious combinations, all of which are powered by her unusual allotment fruit patch.

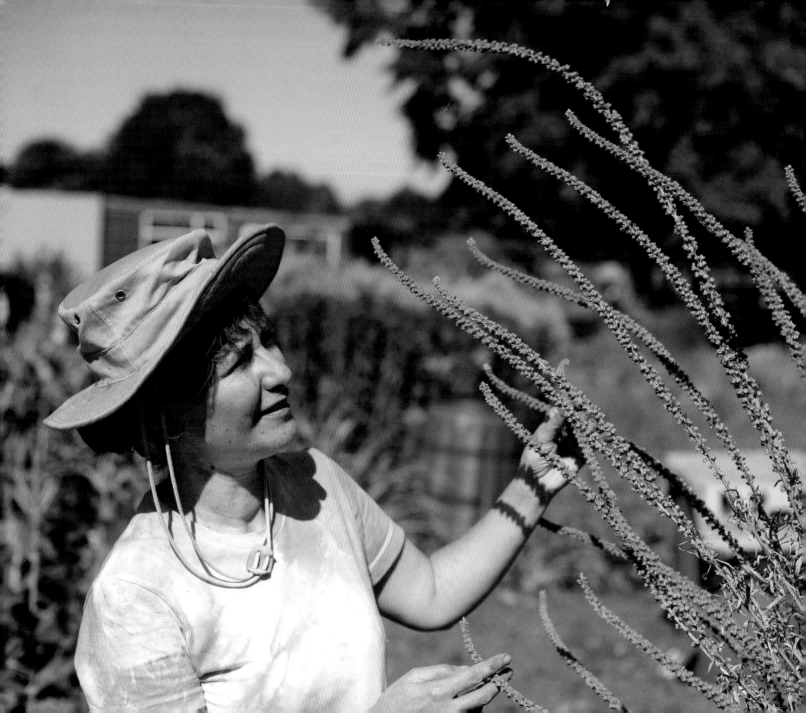

dye-stuffs and weaving

'This was the Vikings' preferred yellow,' says Teresinha Roberts, pointing out a clump of broom growing outside her greenhouse. A greenhouse that, incidentally, is currently being used to dry out a harvest of flax, ready for weaving into soft, silky thread. Though broad beans and potatoes do grow on Teresinha's plot, they play second fiddle to her first love – dye plants. Following a degree in biology, Teresinha undertook a City & Guilds qualification in embroidery. 'I was surprised and disappointed to discover that we only ever use chemical dyes for dyeing fabrics and yarn, so I started to learn about the plants that would have traditionally been used to dye fabrics, and to find out how to grow them.'

Many plants have been tricky to track down but she has slowly filled her two allotment plots with patches of woad for blue, madder for red, sorghum for burgundy and weld for the yellow that the Vikings, apparently, were not so partial to. None of this is simply out of academic interest; Teresinha makes use of every one of these plants, turning them into dyes and using them to create beautiful wool and cotton, which she then weaves into beautiful cloths and turns into blankets or cushions. She even extracts the pigment from woad (she used it to tie-dye her t-shirt blue), despite the complicated process that involves steeping, straining, the addition of wood ash, aerating with an electric mixer, then finally the settling, extraction and drying of the pigment. Her success has led to her setting up a business, making and selling the dyes and selling the seeds so that others can do the same, and she regularly gives talks on the subject.

growing notes

Madder is one of the dominant plants on Teresinha's plot. It spreads low and green across large patches of ground until Teresinha dives in and digs up a root. This is where the pigment is found and the eventual colour – a rich orangey red – is apparent the moment you snap the root.

The colours of some plants are even more obvious: goldenrod (*Solidago virgaurea*) produces a dye the colour of its golden flowers while coreopsis produces an orange colour, halfway between the bands of dark red and yellow you see on the blooms. Others you would never guess: rhubarb roots for yellow and yellow-flowered lady's bedstraw (*Galium vernum*) roots for pink.

Over the past nine years Teresinha has diversified into producing the yarn for the fabrics themselves. Flax took some time to track down, but now that she has found it, she loves using it. 'It's very like turning straw into gold.'

She now also supplies flax seeds to others, including several National Trust properties. In fact, she credits herself with a small revival in flax's fortunes.

In addition, she keeps an army of silkworms at home and collects a bin bag full of mulberry leaves from a tree on the allotment site every day, just before the silkworms form their cocoons. 'I get 100 cocoons a year from them, which is about 10g (⅓oz) of silk. I'm saving it up to make a handkerchief.'

'I love using these colours; they're softer and more natural than any chemical colours. I can grow whatever I like on my allotment, so I choose to grow these.'

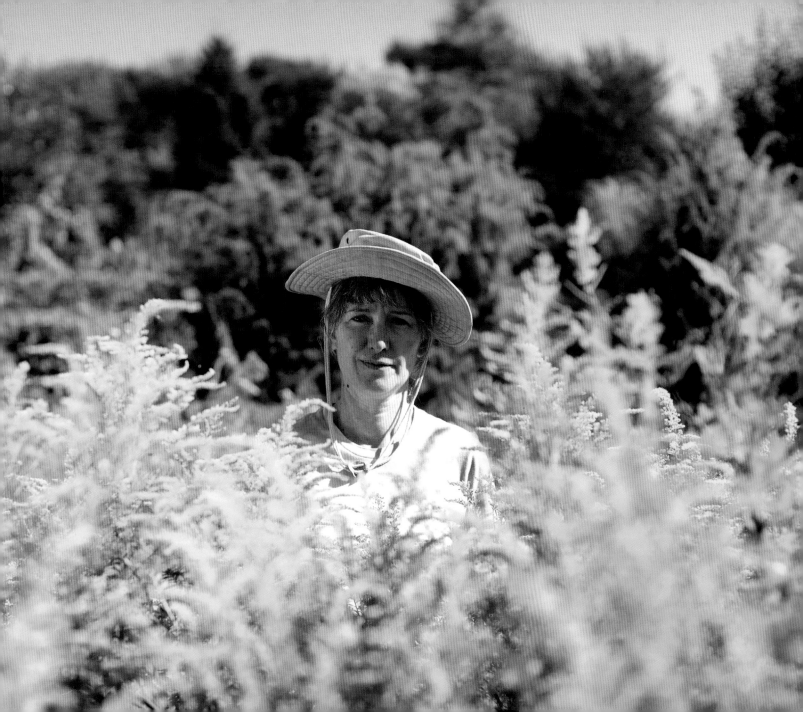

honey from a car park

In some places, Annemie Maes' Brussels edible garden – perched on top of a multi-storey car park – looks like a piece of Mediterranean scrubland, all olive trees, thyme, sage and fennel, and buzzing with bees. Then her careful landscaping comes to an abrupt halt and you can see all too clearly the barren, blank canvas that she started with. 'The rooftop was completely dead. You can see with your own eyes exactly how it was. It's wonderful how nature moves in when you give it a chance.'

But it is the bees that she is most delighted to accommodate. 'This is all for the bees,' she says. Annemie is an artist with a bee obsession. She is fascinated by the way they work together – 'more like cells in a single organism than individuals.'

She produces two crops of delicious honey each year, plus natural honeycomb. The spring-harvest honey is floral and light; the summer one, made primarily from the pollen of the many lime trees that line the Brussels streets, is spicier, with a minty aftertaste.

But the real success of the plot is the bees themselves. Annemie has elevated their status to that of art. She has created maps of Brussels that track their foraging routes (which is how she knows about the lime trees) and has set up hives on other rooftops, the foraging routes of which overlap. Ultimately there will be a bee chain, right across Brussels. Annemie has also created a transparent hive as an art installation and has made many bee videos.

The roof garden feeds Annemie, too, producing olives, alpine strawberries (*Fragaria vesca*), apples, apricots, redcurrants, tomatoes and herbs, but the *raison d'être* of this once-desolate, windswept spot is really as a pantry for her beloved bees.

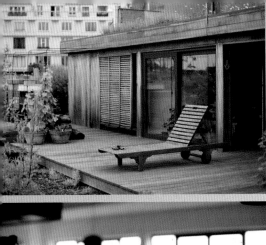

growing notes

'I knew from the start that I wanted to create a real garden up here,' says Annemie, 'not your typical roof garden in containers.' She was helped in her quest by the strength of the roof: built for housing tens of cars, it was easily able to hold the weight of a garden.

A specialist company lined the roof with a waterproof liner, then with a layer of polystyrene and then with a layer of mineral wool. Next they moved in the large olive trees that are such a feature of the roof: they are the only plants in this landscaped part of the roof garden that are still growing in containers. Finally they pumped masses of lava chippings and organic matter onto the roof and sculpted it to create banks, hillocks and pathways, and to cover the olive trees' containers. Then Annemie started planting.

Of course, a great many of her plants are grown for the pollen they provide for the bees, including phacelia, sedum, sage, fennel and winter savory (*Satureja montana*). All of these thrive in the well-drained conditions created by the lava chippings. And a low-growing thyme has found its own way here, a detail that delights Annemie.

Slowly, Annemie is colonising more areas of the roof. She now has a greenhouse on a higher level and a more traditional containerised roof garden for growing vegetables.

But she also finds herself eyeing up the expanses of dead roof that sit alongside her very much alive one, with a view to taking them over as well. 'My work is this garden and the bees. I'm rather in love with my bees.'

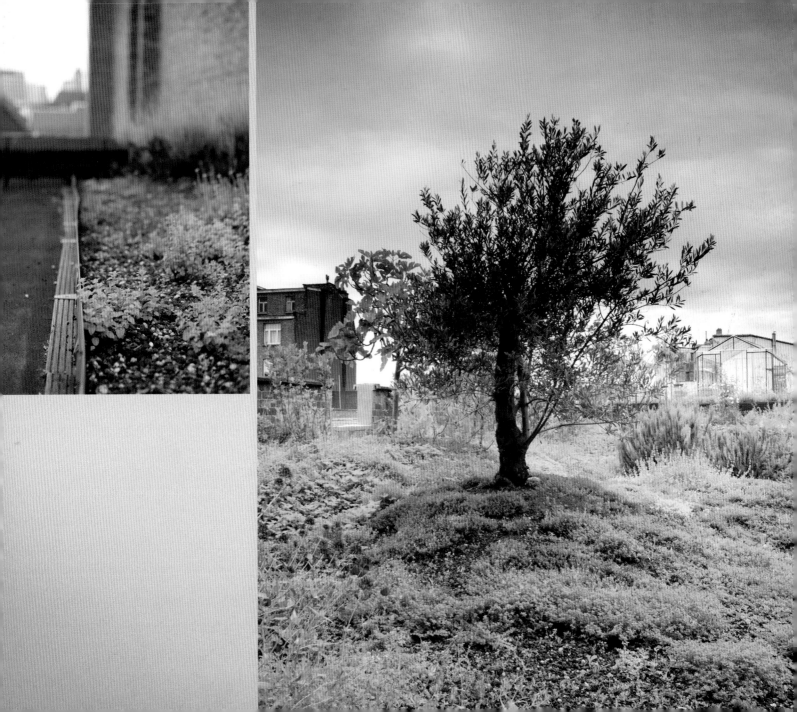

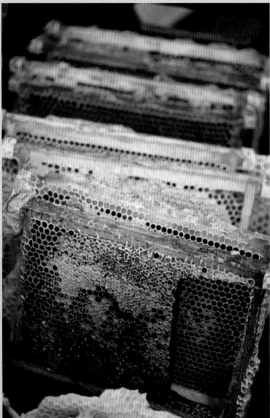
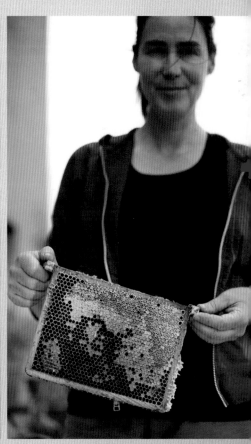

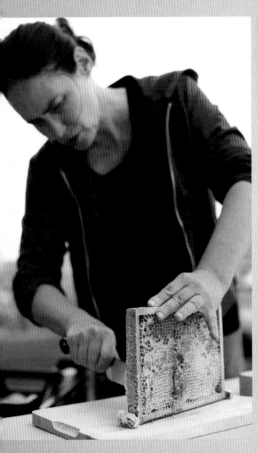
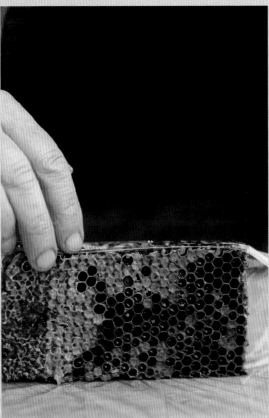
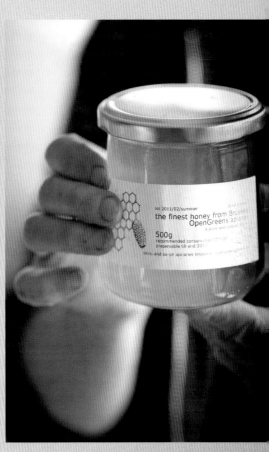

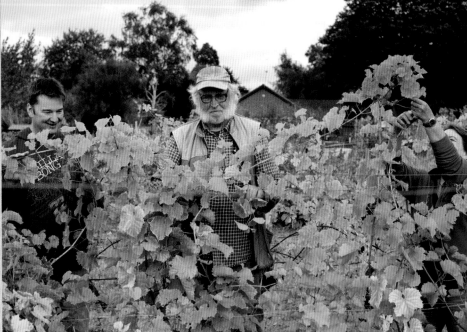

vineyard victory

On an ordinary plot on an ordinary allotment site just inside the M25 motorway grows a mature vineyard. Each neat row contains a different variety: *Vitis vinifera* 'Kerner', *V. v.* 'Pinot Noir', *V. v.* 'Chardonnay', '*V. v.* Seyval Blanc', *V. v.* 'Dornfelder' and more, all heavy with bunches of grapes ready for picking.

The vineyard has been growing here for about 40 years, thanks to the project of a far-sighted allotment holder whose name has been lost in the mists of time. When he became too old to look after the vineyard, the plot was left vacant for a while. 'A few of us plot-holders realised that it was about to be offered to the first person on the waiting list,' says Andrew Evers, 'and that it then risked being stripped of its vines. It seemed such a shame.' So they banded together and approached the allotment committee, which agreed to let them take on the plot for the benefit of all the plot-holders.

The early work that needed doing was intensive. The vineyard had been neglected and 57 large poles had to be hammered into the ground and strung with wires. The vines themselves had got out of shape. Luckily, the group came up with the idea of approaching Denbies, a local wine estate, and asking for sponsorship. 'They've been fantastic,' says Andrew. 'They've paid for three years' rental on the plot but more importantly, they've sent their vineyard manager to visit us each year to advise on pruning and general care. She's made us be fairly brutal with the vines, hacking them right back, but with her help we've got them back into shape now and we should get better and better quality crops from now on.'

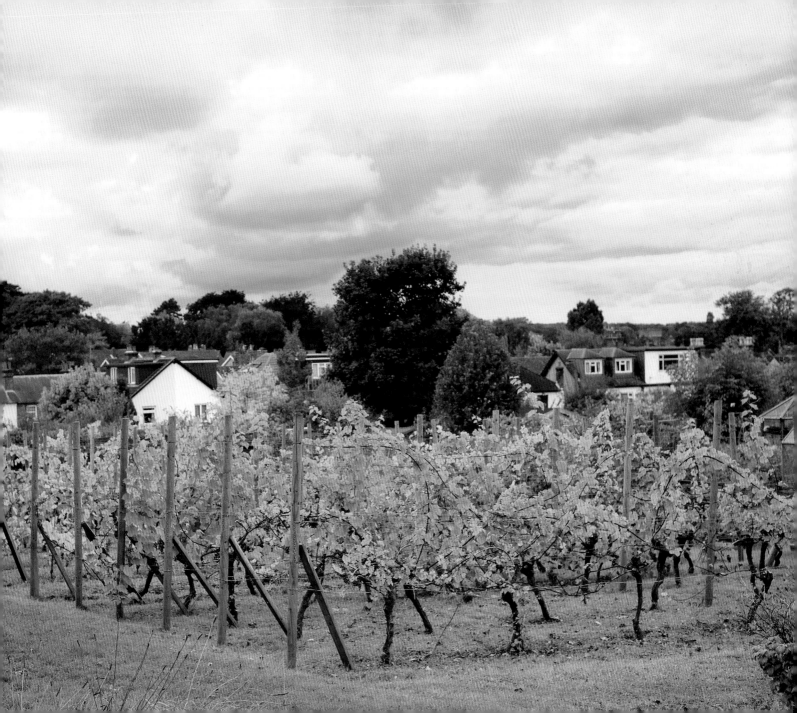

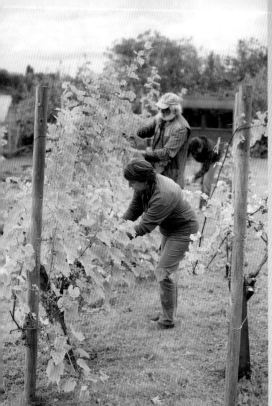

growing notes

There are only a few jobs to carry out on the vineyard plot, and they come in bursts – tying the vines into the wires in summer, pruning in February, mulching the ground in winter and the occasional strimming of the grass. This makes it perfect for communal management, as a large number of people can be rallied to finish a job quickly. Harvesting can be a major job or a disappointingly small one, depending on the summer.

Andrew has always been interested in wine production. His wife is Italian and his parents-in-law have a vineyard of their own. What is more, Andrew worked at a friend's vineyard in Avellino near Naples for a spell.

'Epsom has always been a centre for Italian immigration,' says Andrew, 'so there's a whole stack of people around here who make their own wine. It's part of the culture.'

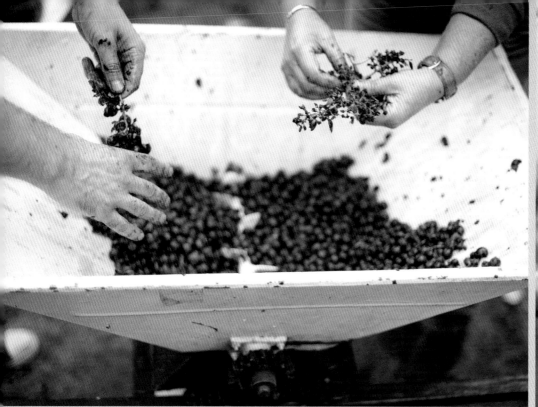

After the group appeared in the local paper, Andrew was contacted and offered some wine-making equipment. 'I thought it was just going to be a couple of demijohns, but this chap turned up with a basket press, a crusher, a stainless-steel vat – the full kit.'

All is stored in Andrew's shed and the group can now make its own wine in Andrew's back garden and has done so for the past three years. To make red wine the grapes are crushed, left in the juice for a few days for the colour to come out of the skins and then fermented in the vat and later bottled up. 'We got about two bottles each last year,' says Andrew, adding, in a slightly surprised tone, 'it was actually quite nice.'

sourcebook

allotment holders' businesses and contacts

chris achilleos
Chris opens his allotment for the National Garden Scheme every year. Visit www.ngs.org.uk/gardens.aspx click on 'advanced search' and type in '94 Marsh Lane'.

rachel baker
Rachel Baker sells her allotment-sourced jams and curds under the name 'With Her Hands' www.withherhands.com

martin crawford
Martin sells forest garden plants through his charity, the Agroforestry Research Trust www.agroforestry.co.uk

horfield organic community orchard
Become a member of the orchard or find out about events www.community-orchard.org.uk

nell nile
View and buy Nell's artwork and find out about her latest exhibitions www.nellnile.co.uk

otter farm
Mark Diacono sells forest garden plants and vegetable seeds shop.otterfarm.co.uk

teresinha roberts
For information on growing natural dyes visit Teresinha Roberts' website at www.wildcolours.co.uk

thai cooking for you
Pheeraya Hill (Nid) runs Thai cookery courses based on the ingredients she grows on her plot www.thaicooking4you.co.uk

luigi valducci brugmansias
Luigi sells brugmansia cuttings and conducts tours of his Brugmansia National Collection. Contact details at www.thegardeningwebsite.co.uk/valducci-brugmansias-speciality-brugmansias-i887.html

cleve west
Garden designer Cleve West's website www.clevewest.com

allotment and gardening organisations

allotment growing
Great site packed full of growing information, ideas and tips, run by experienced grower and author John Harrison. www.allotment.org.uk

amiens hortillonnages
Information about the historic floating gardens at Amiens www.hortillonnages-amiens.fr/

common ground
Common Ground has supported the creation of many community orchards and created Apple Day, which falls on 21st October each year and is an opportunity to celebrate the many varieties of apple that grow in the UK. www.commonground.org.uk

garden organic
The national charity for organic growing, and a wonderful source of information and advice on organic approaches. www.gardenorganic.org.uk

landshare
An organisation that matches people with spare land with people looking for land on which to grow food www.landshare.net

the national dahlia society
Information about growing dahlias for exhibition, and about dahlia shows around the country www.dahlia-nds.co.uk

the national society of allotment and leisure growers

Offers support and advice to allotment holders and works with local and national government in the interests of allotments and allotment holders.
http://www.nsalg.org.uk/

the national trust

The National Trust has created 1000 plots on its properties and more are planned for the future.
www.nationaltrust.org.uk/allotments

the permaculture association

Learn about permaculture principles and find out about permaculture projects around the world.
www.permaculture.org.uk

rhs campaign for school gardening

Supporting schools to develop and use school gardens. Provides teacher resources and a network of regional advisers.
apps.rhs.org.uk/schoolgardening/

the royal horticultural society

The UK's leading gardening charity which runs gardens, shows, campaigns, research and projects. The most comprehensive source of gardening advice.
www.rhs.org.uk

sowing new seeds

Midlands-based organization encouraging and researching the growing of exotic crops on allotments. The charity also collects exotic seeds and has set up a demonstration garden at Garden Organic.
www.sowingnewseeds.org.uk

sheds, tools and equipment

the classic shed company

Beautiful and unusual handmade sheds made from local materials in Norfolk
www.theclassicshedco.co.uk

garden & wood

Antique garden tools and furniture and a tool restoration service
www.gardenandwood.co.uk

labour and wait

Simple, old-fashioned tools and equipment
www.labourandwait.co.uk

niwaki

Beautifully crafted Japanese garden tools and no-wobble tripod ladders
www.niwaki.com

slug rings

The most beautiful way to keep slugs away from your plants. Start shiny copper and turn verdigris with age. Slugs hate copper and so wont climb over these.
www.slugrings.co.uk

seeds and plants

arne herbs

Suppliers of herb plants by mail order
www.arneherbs.co.uk

jungle seeds

Source of many exotic and unusual vegetable seeds, including callaloo and Thai eggplant
http://www.jungleseeds.co.uk

organic plants

Plug plants of a great range of vegetables, sent out in perfect condition and just in time for planting out.
www.organicplants.co.uk

real seeds

Seeds bred in Wales to thrive in cool and damp summers. Many early flowering and fruiting varieties.
www.realseeds.co.uk

seaspring seeds

Chilli breeders and growers who have worked closely with Nid to bring out new varieties. Buy chillies as seed, plants or fruits in season.
www.seaspringseeds.co.uk

credits

We would like to thank all the owners for allowing us
to photograph their 'cool allotments'.

All photography by Mark Diacono.
www.otterfarm.co.uk

acknowledgements

Lia Leendertz and Mark Diacono would like to thank the plot-holders who gave up their time and stories, who gave access to their plots and who were unfailingly helpful, generous and interesting.

A number of people helped to put us in contact with our plot-holders but do not appear in the book themselves, so particular thanks to: Betty Farrugia at Walsall Road allotments, Birmingham; Balbir and Malcolm Currie at Uplands, Birmingham; Ursula Makepeace at Beer Allotments, Devon; Jo Johnson and Barney White at Edgbaston, Birmingham; Sarah Cuttle and Paula McWaters, and to Anton Rosenfeld at Sowing New Seeds; and Jeanette Heard at the National Trust.

Thanks go also to those whom we were eventually unable to visit for logistical reasons: Rachael Allen at Soil & Ink; Marie Murray at Dalston Eastern Curve Garden; Andrew Merritt at FARM:shop Hackney; Su Johnston and Stephen Finch at Grace and Flavour; Alison Findlay at the RHS; Leyla Laksari at Living Under One Sun; Sarah McFadden at Budgens Food from the Sky; Peter Tasker at Monk Coniston; and Bill Wilson at St Mary's, Isles of Scilly.

And finally, huge thanks to Fiona Holman at Pavilion for your calm and steady guidance throughout. Jobs like this don't come along very often. It's been a treat.

lia leendertz

Lia Leendertz is a freelance garden writer who shares an allotment with several friends near her home in Bristol. A regular contributor to *The Guardian* and *The Telegraph*, Lia is also columnist for gardening magazines *The Garden* and *Gardens Illustrated* and author of several books, including *The Half Hour Allotment*. She writes an award-winning gardening blog, Midnight Brambling.

mark diacono

An award-winning writer and photographer, Mark Diacono runs Otter Farm (www.otterfarm.co.uk) and led the garden team at River Cottage and appeared in the TV series. He was Garden Journalist of the Year and Garden Book Photographer of the Year at the Garden Media Awards in 2011, and has collaborated with Lia Leendertz on previous books.

Additional captions: page 1 french floating garden; pages 2–3 food resliience in a welsh village; page 4 portable tropical garden; page 6 practically perennial; page 9 moonstruck jamaican; page 10 keeping with tradition; page 38 portable tropical garden; page 60 edible bus stop; page 90 practically perennial; page 116 thai treasures; page 134 dye-stuffs and weaving; page 160 tempura and teppanyaki

First published in 2013 by Pavilion Books
An imprint of Anova Books Company Ltd
10 Southcombe Street
London W14 0RA

www.anovabooks.com

Commissioning editor Fiona Holman
Photography by Mark Diacono
Design Steve Russell
Editor Hilary Mandelberg

A CIP catalogue for this book is available from the British Library

ISBN 978-1-862-05966-5

10 9 8 7 6 5 4 3 2 1

Colour reproduction by Dot Gradations Ltd, UK
Printed and bound by 1010 Printing International Ltd in China